ST ALBANS
IN 50 BUILDINGS

KATE MORRIS

AMBERLEY

About the Author

Kate Morris lectures and writes on historical topics, having a special interest in the social history of the long eighteenth century. Having studied history at both Edinburgh and York universities, she had a lengthy career as a librarian and linguist before establishing her own business offering English language development and cultural induction to foreign-speaking business personnel. She is a former Mayor of the City and District of St Albans, a city in which she has lived for the past forty-five years.

First published 2018
Amberley Publishing, The Hill, Stroud
Gloucestershire GL5 4EP
www.amberley-books.com
Copyright © Kate Morris, 2018
The right of Kate Morris to be identified as the Author of this work has been asserted in accordance with the Copyrights, Designs and Patents Act 1988.
Map contains Ordnance Survey data © Crown copyright and database right [2018]
British Library Cataloguing in Publication Data.
A catalogue record for this book is available from the British Library.
ISBN 978 1 4456 7739 2 (print)
ISBN 978 1 4456 7740 8 (ebook)
Origination by Amberley Publishing.
Printed in Great Britain.

Contents

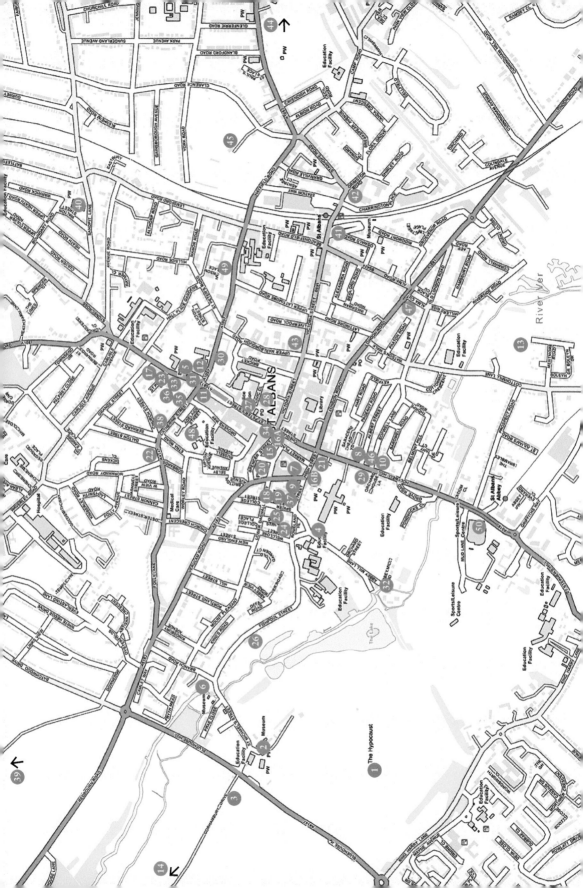

Key

How to Use This Book

The buildings are listed in chronological order as they appeared in the history of the town by date of construction, which indicate original building dates and any subsequent significant rebuilding. The map enables you to find the buildings within the book as the key uses the same numbers as the text. Before visiting any of the buildings it is advisable to check their websites for opening hours and access.

Acknowledgements

I am grateful to the many colleagues, family and friends who have supported me and contributed to this book. In particular, the patience of David Smart, the photography of Kari Lundgaard and reviews of the text by David Thorold and Jon Mein have made the whole exercise possible and I thank them for lending their expertise. The museum staff and colleagues in the St Albans and Hertfordshire Architectural and Archaeological Society (SAHAAS) have been ready and willing to answer questions and source images, which have helped me to tell the story of a town that epitomises the history of England over so many eras through its built heritage. I am especially grateful for the use of the photographs taken by Richard Darnell, which are now part of the SAHAAS library collection. Every effort has been made to check and acknowledge the rights for each image reproduced in the book. Any errors that have occurred or assumptions made are my own.

Introduction

'Verulamium' was the name given by the Romans to a settlement on the marshy ground by a crossing of the River Ver, already the home of the Catuvellauni tribe and known as Verlamion. It was to become one of the three largest and most important Roman cities in Britain, with the designation 'municipium'. It was to be the site of the martyrdom of Roman citizen Alban, on his refusal to deny his support for the Christian priest Amphibalus. It is the shrine to Alban, and subsequent establishing of a monastery, that has given the present-day city of St Albans its name. Verulamium was substantially excavated by, amongst others, Sir Mortimer Wheeler and his wife Tessa in the 1930s, but much still remains to be explored, particularly that part of the city now under the Gorhambury estate. Of special interest there is the only visible Roman theatre in Britain, which can be visited, and there is often a tour guide on hand to interpret the remains. Finds from excavations of the whole city are housed in a museum on the edge of Verulamium Park, which is also a building of interest in its own right.

Following the withdrawal of the Roman Army from Britain in the late fourth century, Verulamium slowly declined, although it continued to be occupied. In the eighth century, the supposed site of Alban's shrine on the hill above the town was chosen by Offa, King of Mercia, for the founding of a Benedictine monastery, which gave rise to the modern town of St Albans. The Norman Conquest saw the redevelopment of so many institutions in England, and St Albans monastery was no exception. It was rebuilt, largely with bricks from the ruins of the Roman city below. It rapidly became the premier abbey of the land, its mitred abbot answering only to the Pope in Rome, but its dissolution by Henry VIII in 1539 brought further change to the town. Whilst the conventual buildings were, in the main, destroyed, the church was bought by the Corporation, which had been newly established under a charter granted by Edward VI in 1553.

The economy of the town now focussed on the Abbey's market and control lay with the mayor, supported by ten of the 'discreater and better men', determined as the principal burgesses, later called Aldermen, and twenty-four assistants, who would advise on municipal matters.

The town's proximity to the capital on a major route to the North had made the town an obvious stopover for packhorse trains and travellers alike and its inns thrived on that business until improvements in both highways and vehicles allowed longer distance journeys in a day, and reduced the need for overnight accommodation here. It also became a convenient out-of-town residence for those with business interests in the City of London or Westminster, and, by the eighteenth century, a tourist destination. It became fashionable amongst the gentry, and classical-style town houses in brick with new sliding sash windows began to appear, replacing old timber-framed and thatched buildings, or updating them with new brick façades. They represented the style of the day and were a lower fire risk than the traditional buildings.

The town thrived until the new railway network completely passed it by. No canal system came near as there was little industry here to warrant such investment. The town recovered after this low period shortly before the middle of the nineteenth century, when rail connections were finally made, first to Watford and Hatfield and then finally directly to London at St Pancras. The direct link with the capital ensured St Albans' future as a commuter town and it has been under pressure for development ever since.

Despite this pressure, much has been conserved in the town, which remains to tell the story of its full and interesting heritage. The whole of the town centre is now designated a Conservation Area, and a Character Statement, which reflects the significance of many of the buildings, can be found on the website of St Albans City and District Council.[1] With upwards of 400 listed buildings in the town, and many more, which have significant interest, the choice of fifty to illustrate the history of the town is a difficult one. However, the history of the town is worthy of the telling in each era of the country's history as a whole, and, remarkably, sufficient remains to reflect each of those periods. By first reading about the town's built heritage and then exploring fifty of the town's key buildings on foot, the reader will be provided with an overview of the history not only of this town, but that of the nation as a whole. The lives of some of the buildings' inhabitants give a flavour of the town's social history, which is no doubt typical of that of many market towns in England over the centuries, though this one has the added interest of close proximity to the nation's capital. The chronological account of the town's development highlights each of the fifty buildings as they appear in the story. Each can then be found on the map for those interested in visiting them. A deeper insight into the architectural history of most of them can be found in Pevsner's Guide.[2]

Kate Morris, 2017

The 50 Buildings

From Roman Verulamium to Benedictine Monastery

Apart from a section of the old wall of the Roman city, only the floor of a part of one town house can still be seen in situ in Verulamium Park.

1. Mosaic Floor and Hypocaust of a Roman Town House

When complete, the villa was some 200 ft long. Under the mosaic floor of the one remaining room can be seen part of the hypocaust heating system. In 2005, following an architectural competition, a new building, designed to better conserve and display the mosaic, was opened by Lord Salisbury. At the time, he was interested to highlight the hypocaust system, since, having not long since inherited his ancestral home at nearby Hatfield, he had the challenge of modernising the nineteenth-century version of central heating, which came with his inheritance! The new building provides a twenty-first century contribution to the

Mosaic floor of a Roman town house at Verulamium, showing the hypocaust system. (Courtesy of St Albans Museums)

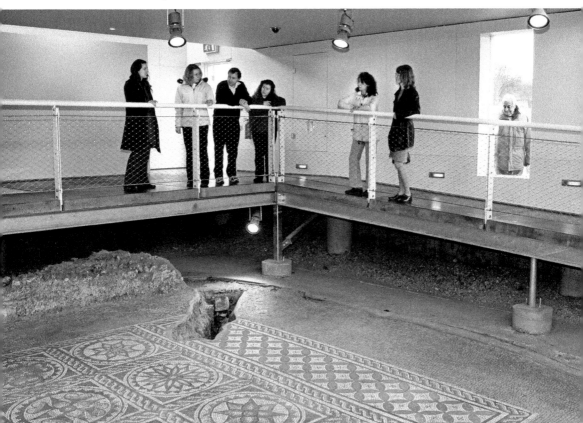

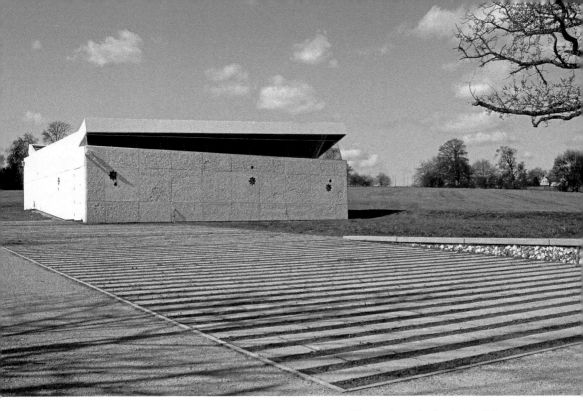

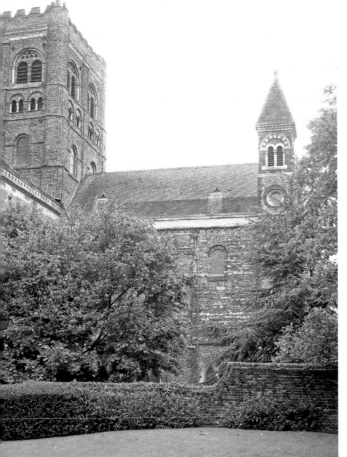

Above: Award-winning building housing the mosaic floor of the only remaining Roman building visible in situ in Verulamium Park. (Courtesy of St Albans Museums)

Left: Tower of the cathedral and abbey church built with bricks taken from the ruins of Roman Verulamium. (Kari Lundgaard)

built environment of the city and, though not without controversy in this city of tradition, it won an award from the city's Civic Society. Certainly distinctive and offering much greater accessibility to the remains, the new building provides an insight into the city's Roman heritage free of charge during the opening hours of the nearby museum.

<div align="center">*</div>

The Roman city site has been robbed systematically over the centuries and its fabric used as construction material for subsequent developments. Roman bricks can be easily identified in the tower of the cathedral today. As interest in antiquity grew in the seventeenth and eighteenth centuries, gentry and aristocrats alike avidly collected artefacts, both on their Grand European tours and wherever antiquarian sites were identified in Britain. In 1729, figures and Roman tiles were discovered during works in the Abbey Orchard, which made national news, being reported in the *Newcastle Courant* on 28 June as a bust of King Offa and his Queen in 'basso relievo'. In 1737, Hugh Boulton boasted that 'all Travellers, as well as the accustomed Guests, may be sure to have good Entertainment and civil Usage' at his Crown Inn on Holywell Hill. He had on display 'for the Entertainment of the Curious … several Pieces of Antiquity, which were Dug out of the Ruins of the Ancient City of Verulam, and the Monastery of St Albans.'

2. The Verulamium Museum

The Museum houses the finds of recent excavations at Verulamium, on land which was previously part of the Gorhambury estate, but transferred to council ownership. It was built by local builder J. T. Bushell and opened in 1939 by the Princess Royal. Arguably the finest encapsulation of Roman Britain, the volume of visitors and modern requirements

The Verulamium Museum, opened in 1939, housed finds from excavations undertaken before the park was laid out. (Kari Lundgaard)

THE VERULAMIUM MUSEUM

BUILT BY

J. T. BUSHELL LTD.

Builders and Contractors

53, CATHERINE STR., ST. ALBANS

TELEPHONE 365

OTHER WORKS include

HOSPITALS and HOMES
CHURCHES and SCHOOLS
PUBLIC HALLS and CLUBS
CINEMAS and PAVILIONS
HOTELS and PUBLIC HOUSES
SWIMMING BATHS and POOLS
FACTORIES and WORKSHOPS
PERMANENT A.R.P. SHELTERS
HOUSES and SHOPS
RESTORATION WORKS

Left: Verulamium Museum was constructed by local builder J. T. Bushell. (Courtesy of St Albans Museums)

Below: Cranbourne Primary School pupils visit Verulamium Museum. (Kari Lundgaard)

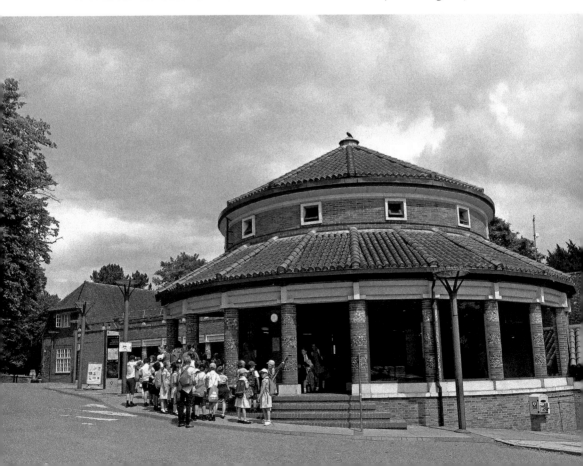

dictated additional facilities by the end of the twentieth century. A major fundraising exercise allowed the construction of a new and welcoming foyer, complete with shop and cloakroom facilities, which was opened by Lord Puttnam CBE in 1999. The style of this extension very appropriately anticipates the Roman scene that is so well portrayed inside the building, and this building too was a recipient of the Civic Society's annual award for an outstanding contribution to the townscape. The museum continues to welcome school parties and individual visitors in large numbers and is nationally accredited.

3. The Roman Theatre

Although modern geophysical methods have shown up some new information concerning the Roman city, there is still no more to be seen in the park. Little more is visible on the rest of the Gorhambury estate, except for the theatre. No doubt in due course more will be revealed under the fields of the estate as archaeological opportunities arise there, but in the meantime the theatre is a huge attraction, being the only one in Britain to be fully excavated. Built early in the establishment of this Roman settlement, its stage distinguishes it from the many amphitheatres known. It was surrounded by shops and houses, and during excavations some excellent craft work was found in the rubble, including the beautiful Venus statue on display in the Verulamium Museum. The 8½ in bronze statue was discovered in 1959 in a box in what would have been the cellar of a metal worker's workshop. She would have been made around AD 200 for a household shrine and still charms today (she has been stolen from the museum twice since she was first uncovered, though on each occasion she was clearly found to be too

Remains of the Roman theatre at Gorhambury. (Courtesy of St Albans Museums)

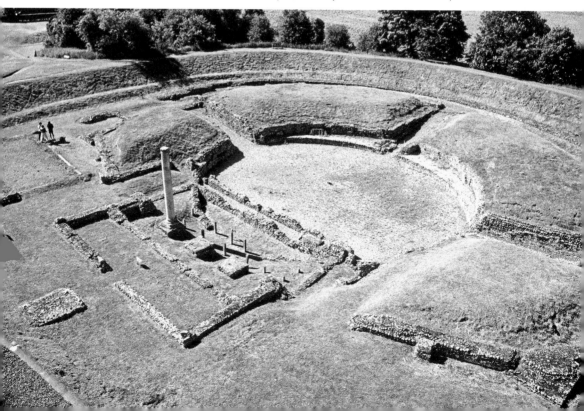

hot to handle and was anonymously returned to her resting place at the museum for us all to continue to enjoy).

<div align="center">*</div>

Many villas and temples have been discovered in the area around St Albans, though little has been found in what is the modern city. Cemeteries were located outside the city walls, as were executions sites. We know of the execution of Alban (the citizen who chose not to recant his Christian faith), who was arrested in the course of sheltering the priest known as Amphibalus. It took place to the north–east of the city, possibly on high ground now known as Oysterfields, though long assumed to have been where our beautiful cathedral now stands.

Bronze statue of the goddess Venus from Roman Verulamium. (Courtesy of St Albans Museums)

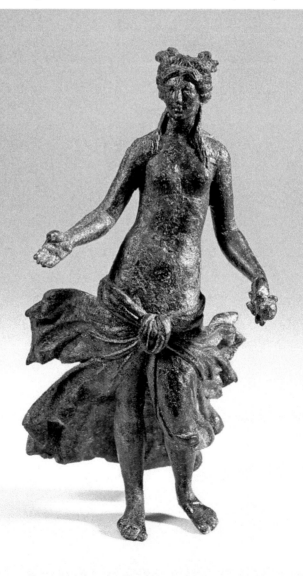

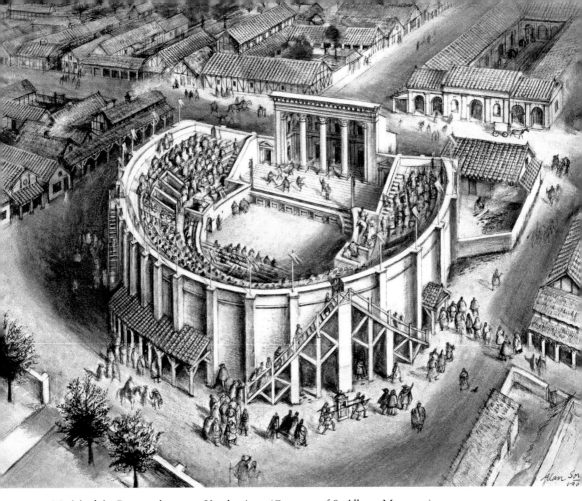

Model of the Roman theatre at Verulamium. (Courtesy of St Albans Museums)

St Albans' Medieval Heritage

4. The Cathedral, Abbey Gateway and St Albans School

Little is known of the building of Offa's Benedictine foundation, although it is thought to have had more or less the same footprint as its Norman replacement. (Enough of Abbot Paul of Caen's work still remains to remind us of the powerful changes that the Norman Conquest brought to England.) With little local stone available for building purposes, flint stones from the fields were combined with rubble from the brick buildings of the old Roman city to create a complex of conventual buildings and a massive church within the boundaries of the Abbey. The Romanesque church was decorated with wall paintings, some still visible today, despite the plundering and destruction caused by the Civil War and the Reformation. The shrine to Alban, the first British Christian martyr, made the monastery a much favoured destination for pilgrims. Located behind the High Altar, it was protected from a watching loft, still there, the only such wooden example known. Approach could have been through the Great Gateway or through the Waxhouse Gate, where candles could be obtained to be lit before the shrine itself.

Cathedral and abbey church of St Albans. (Kate Morris)

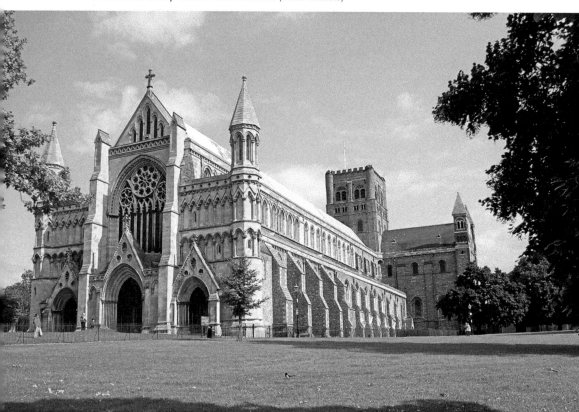

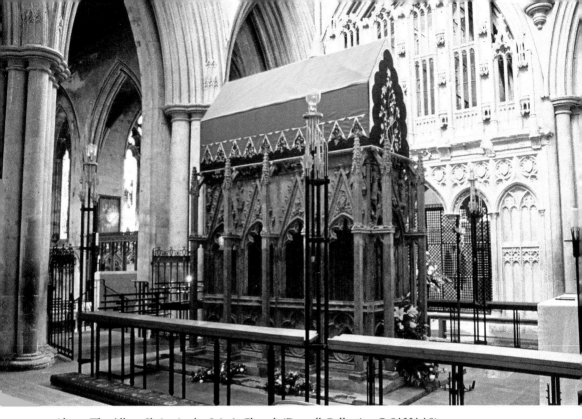

Above: The Alban Shrine in the Saint's Chapel. (Darnell Collection © SAHAAS)

Below: The Great Gateway to the monastery. (Kari Lundgaard)

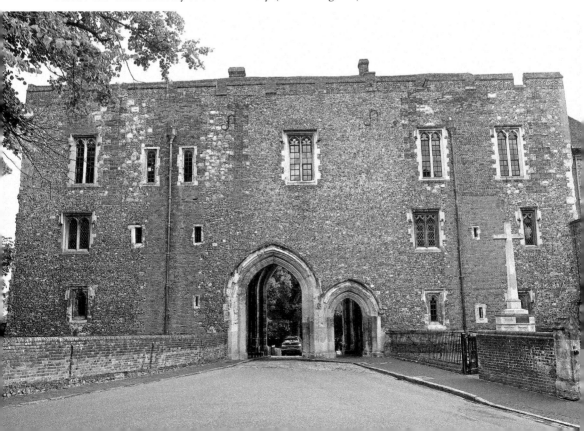

The imposing Gateway building is still in use as part of St Albans School. The school moved to that building when the abbey church became a cathedral and an extension was built soon after by architect Samuel Flint Clarkson. The Lady Chapel, where the school had been since 1553, was reunited with the rest of the church. The Liberty Gaol and House of Correction, which had previously occupied the Gateway, was closed following the opening of the Victorian prison. Despite its mighty appearance, the abbey church was less than robust and repairs were needed from an early date. That each renovation was completed in the favoured style of the day presents a timeline of the architecture of several generations. The whole of the south side of the nave has had to be reconstructed and is now in Gothic style, and Lord Grimthorpe's restoration of the late nineteenth century has given us the present West End. There is no doubt that Grimthorpe's funding saved the fabric of the abbey church and facilitated essential works at the other three ancient parish churches, work long recognised as significant and necessary nationally.

St Albans and Hertfordshire Architectural and Archaeological Society (SAHAAS, first known as The St Albans Architectural Society) was founded in 1845 specifically out of concern for the conservation of the abbey church and other such monuments. Not long after, the campaigns of William Morris and others led to establishment of the Society for the Protection of Ancient Buildings (SPAB), still a highly influential voice concerning conservation of our built heritage today. The will has always been there, though funding has been an inhibiting factor. Grimthorpe's still-controversial contribution at the abbey

Samuel Flint Clarkson's extension to St Albans School, following the school's removal to the Abbey Gateway. (Kari Lundgaard)

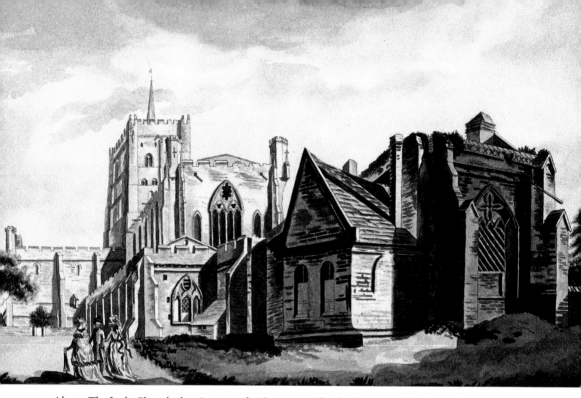

Above: The Lady Chapel when in use as the Grammar School. (Courtesy of St Albans Museums)

Below: The West End of St Albans Cathedral. (Kari Lundgaard)

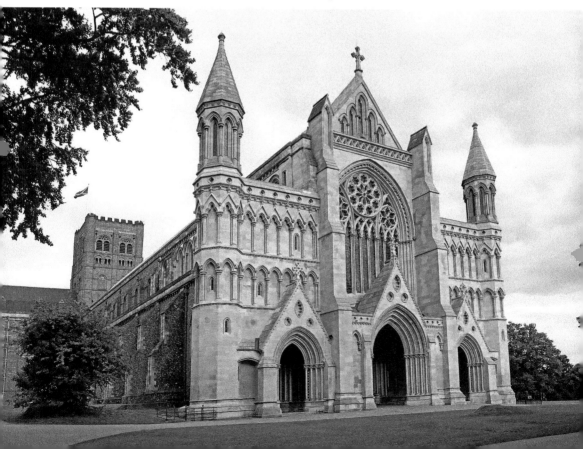

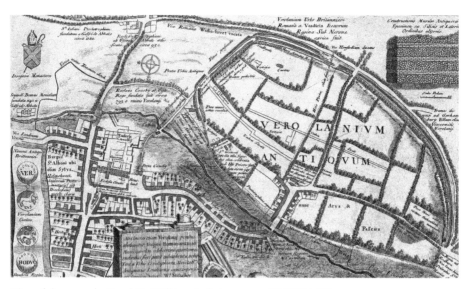

Plan of the town by Revd Dr William Stukeley, 1721. (© SAHAAS)

church has brought the opportunity for the building to play its significant role as a Diocesan cathedral, which brings peace and pleasure today to both congregation and visitors alike.

The lack of good locally available building materials is also responsible for the almost complete absence of ruins of the ancient monastery here. What remained of the conventual buildings following the dissolution of the great abbey was plundered again and again for buildings elsewhere in the town. It is even reported that the medieval wall surrounding the monastery had been dismantled already in the fourteenth century and the materials used for other purposes. This would have obscured the boundaries between houses or tenements built along the street outside the monastery and the Abbey grounds themselves. The King's stables on the west side of Abbey Mill Lane were retained after the dissolution and certainly in use during the Civil Wars of the mid-seventeenth century. The Great Gateway was put to use as a gaol for the Liberty of St Albans, a separate jurisdiction for the Abbey's lands outside the borough, which remained distinct until the nineteenth century.

At the time of the visit of antiquarian Revd Dr William Stukeley in 1721, Waxhouse Gate still stood, opposite the town's clock house in the Market Place. The gate was an octagonal structure, crenellated, as had been the medieval walls. Stukeley found sufficient during his visit to draw a plan of the town, including Verulamium.

<p style="text-align:center">*</p>

During the early history of the monastery, the three ancient parishes of St Michael, St Peter and St Stephen were founded. We still see their churches today, albeit much modified, not least by Lord Grimthorpe, in common with the fate of the abbey church.

5. St Peter's Church

The church of St Peter is the only one of the three parish churches, which lies within the ancient borough boundary. At the north end of tree-lined St Peter's Street and the market, it

has served the community for over 1,000 years. Its vast churchyard is the final resting place of many citizens of the town, there being so little burial ground around the abbey church. Now a closed churchyard, its footpaths provide off-road access to the city centre and market from the northern and eastern suburbs and its benches quiet resting places for a short break en route. The church itself, though Saxon in origin, has suffered more changes than the other two. Towards the end of the eighteenth century the building became unsafe, with the vicar ultimately refusing to conduct services until the tower could be better supported. Wooden supports were introduced, but by 1803 there was no other choice than to conduct major restoration work, including truncation of the chancel. This solved the problem but by the end of the nineteenth century a further sum was needed to secure the building once more. The vicar, Revd Horatio Nelson Dudding, a supporter of the Temperance Movement, cast around for a source. Sir John Blundell Maple of Childwickbury, head of the Tottenham Court Road Maple furniture empire, was a possible benefactor, but Dudding was unsure of accepting Maple's money, since he also bred racehorses at his Childwickbury Stud. Lord Grimthorpe came to the rescue, but here too sought to replace the West End. In this case, it also meant removal of the early eighteenth-century gallery and organ, since he claimed the West End was no longer a fashionable location for a church organ. This was a controversial proposal but one which was forced through.

*

At its height the monastery controlled much of the western part of the county of Hertfordshire. During the fourteenth-century economic turmoil following the devastation of the Black

Below left: St Peter's Church. (Kari Lundgaard)

Below right: Distant view of St Peter's Church from the clock tower on Market Day. (Kari Lundgaard)

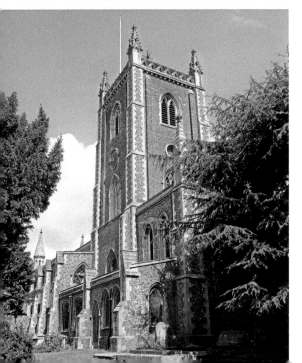

Death, Abbot Thomas de la Mare undertook substantial investment in the various manors to encourage his tenant farmers. Several great barns for the storage of crops were built either by him or possibly by his cellarer and prior, John Moote, some of which survive today.

6. Kingsbury Barn and Mill

The manor of Kingsbury in St Michael's was long part of the Gorhambury estate. In recent times, manor house, mill and barns have all been in separate occupations. The mill, renewed in the eighteenth century, still has its operational parts, though is now run as a very popular Waffle House. The great barn has been dated by dendrochronology at 1374. It was most recently used by the Express Dairies as garaging for their milk floats, but it has now been reunited with the manor house and lovingly restored. Its owners kindly make it available for community events. The remainder of the dairy site has been redeveloped for housing.

*

Though the Abbot reigned supreme over his tenants, the community that grew up around his market was not without a voice. It was their initiative to build a clock house, which could be their base in the market place itself.

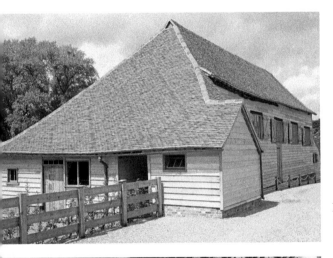

Kingsbury Barn restored in 2009. (Courtesy of Adam and Jill Singer)

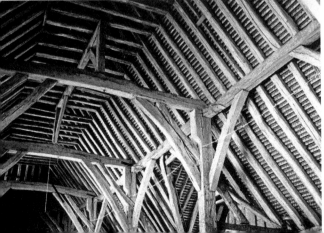

Roof structure of the fourteenth-century Kingsbury Barn. (Darnell Collection © SAHAAS)

Above: Kingsbury Mill with Hertfordshire puddingstone. Puddingstone is unique to the area and small pieces of the hard stone were sometimes used for luck by local builders. (Kari Lundgaard)

Below: The 1930s Express Dairy building on the Kingsbury site, now redeveloped for housing. (Kari Lundgaard)

7. The Clock Tower

Built by 1405, the St Albans Clock Tower has served the town ever since, though is now reduced to museum status. Less common than on the Continent, such belfries have never been numerous in England. One existed at Westminster, but has not survived, leaving the St Albans tower unique in the country. Providing a magnificent view from the top of its ninety-three steps, it offered a signal point when the threat of invasion by Napoleon required fast communication between Portsmouth to the south and Yarmouth to the east. It was said that news could be conveyed to Yarmouth and back in only five minutes. The tower's ancient bell, Gabriel, was traditionally rung to wake the apprentices at 4 a.m. for work and to signal the curfew, when all fires were to be doused in the evening. Gabriel is too fragile to be rung today, but the market bell is still rung by the first and last young visitor on open days. In 1700, in considering its need for a market hall, the Corporation considered pulling the tower down. In the end, only the Eleanor Cross was demolished to make space for the new Market Cross. The water pump later gifted by Earl Spencer stood under it until the nineteenth century, when both were replaced by a water fountain, the gift of widow Mrs Isabella Worley. This too was later moved on account of its obstruction to

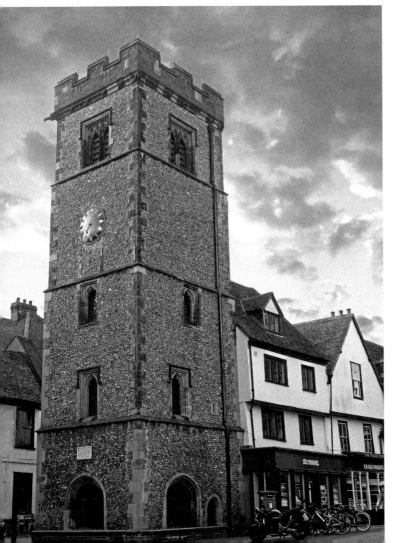

St Albans Clock Tower.
(Photo Kari Lundgaard)

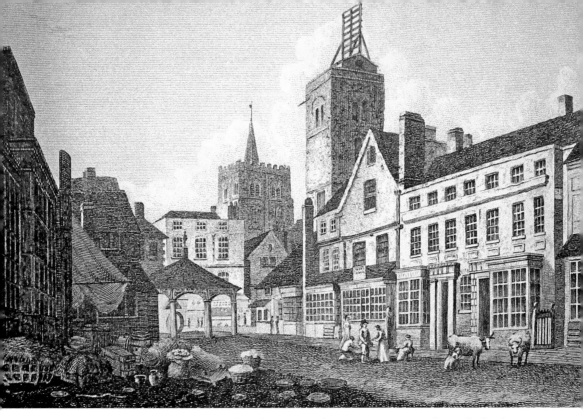

Clock tower with signalling system and Market Cross with water pump in 1812, by G. Shepherd. The 'Hertfordshire spike' on the abbey church tower was removed in 1832. (Courtesy of St Albans Museums)

traffic as that inexorably increased. Despite the frequent need for costly repair, any similar suggestion for demolition or removal of the Clock Tower (such as that by the local press a few decades ago on 1 April) has been met with outrage by the local community.

*

Shops grew up against the walls of the monastery and guest houses and inns on the other side of the road, with yards for stabling of horses and storage of goods provided behind. We still have very clear evidence of this town plan.

S. The White Hart Inn

The yard of the White Hart Inn on Holywell Hill stretched back to where the White Hart Tap is at Keyfield today. Service personnel at the inns could obtain their refreshments at a 'tap' such as this, though this public house was built in 1837, probably to serve the increasing population in this area. The White Hart itself is a good example of the medieval hostelries in the town. With twenty-six beds and stabling for fifty horses recorded in the mid-eighteenth century, it was regarded as the best inn in town and was quite often used as a venue for Corporation meetings. It has hosted innumerable celebrities, including, in 1770, the notorious Duke of Cumberland, brother of George III, for assignations with his lover, Lady Grosvenor. The episode, testified to by the inn's landlady and chambermaid, cost the Duke £10,000 in damages to the lady's husband.

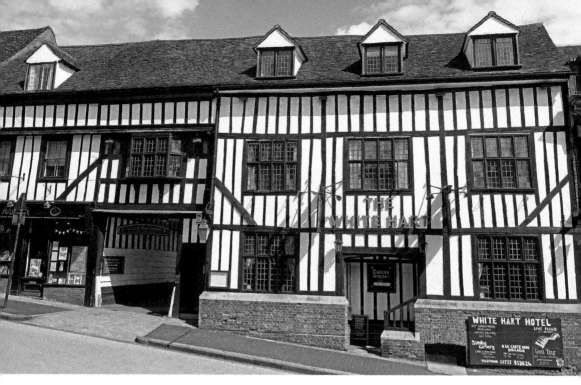

The White Hart Hotel. (Kari Lundgaard)

9. The Tudor Tavern

The building on George Street that now houses the Thai Square restaurant was for a long period known as the Tudor Tavern and is a charming reminder of those times. The exposed and highlighted posts and beams enhance the appearance today, but would, in their heyday, have been plastered. Some had brick frontages added in the eighteenth or nineteenth centuries to meet the dictates of fashion and fire prevention. The Tudor Tavern building was lost to the hospitality trade over much of its history, spending a century at least as shop premises.

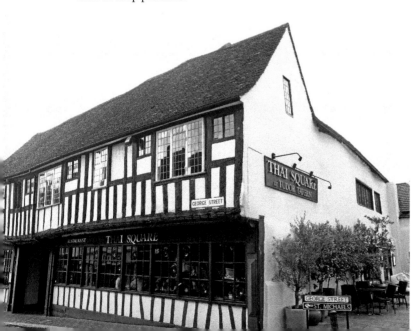

Thai Square, formerly the Tudor Tavern, George Street. (Kari Lundgaard)

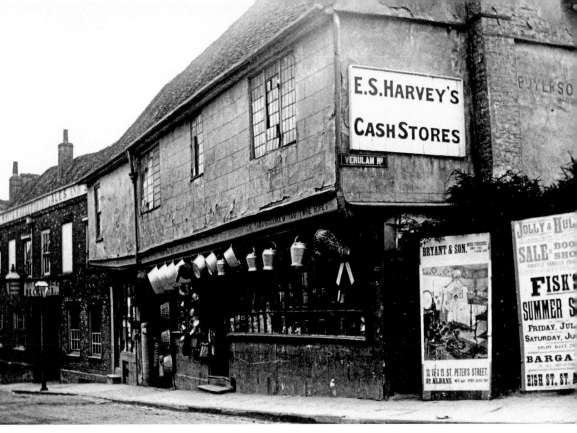

E. S. Harvey's Cash Stores in the early twentieth century, now the Thai Square restaurant. (Courtesy of St Albans Museums)

10. The Crane Inn, Corner of Holywell Hill and Sopwell Lane

At Nos 37–39 Holywell Hill is a late fifteenth-century hostelry. Variously known as The Crane, The Chequers, and finally The Crown and Anchor, a traffic accident in the 1950s put paid to its hospitality role. Its corner was rebuilt as a shop, first for an antiques dealer and then an estate agent, though now it is incorporated in one of the fine houses within its curtilage.

The former Crane Inn on Holywell Hill. (Kari Lundgaard)

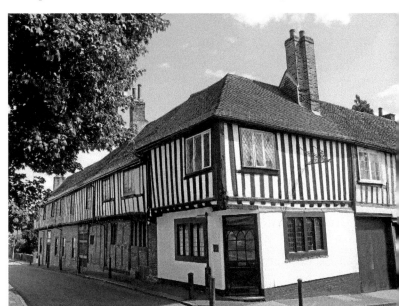

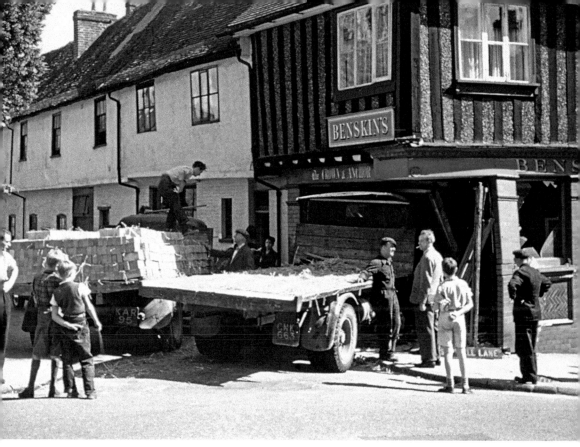

Traffic accident at The Crane. (Courtesy of St Albans Museums)

There is little left of domestic buildings from the medieval period in St Albans today, though there are still some modern houses and shops, which retain elements that can be dated earlier than 1600.

11. Café Roma and Subway, No. 79 St Peter's Street

The building at the corner of Adelaide Street and St Peter's Street, which houses Subway and the Café Roma, is the cross wing of a hall house originally open to the roof, probably of the sixteenth century. A decoration on one of the wing's beams suggests it was the location of the best chamber of the early house. The building was, in the nineteenth century, an inn known as The Adelaide. It closed and was sold in 1961, and was almost lost. Adelaide Street, named for King William's Queen, was the redevelopment, in the 1830s, of another property on St Peter's Street. That was a time of much reform and concern for relief of the poor and the new housing provided for many who might otherwise have been living in miserable lodgings in the town's inn yards. Narrow as most side streets in the town were, Adelaide Street was considered for widening in the 1960s. Had the building been demolished following closure as expected, the Adelaide site would have lost 9 ft to the road widening. That prospect did not appeal to the site's purchaser and the building was refurbished instead, allowing us to enjoy its history today.

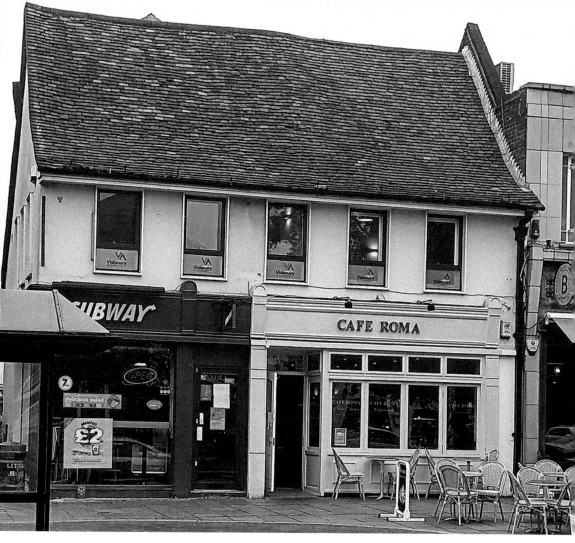

Above: Cafe Roma and Subway. (Tim Morris)

Below: Decorated beam – one of the timbers of the early hall house. (© SAHAAS)

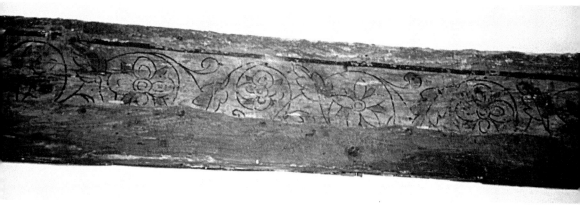

12. Nos 66–76 Church Green, St Peter's Street

A recent archaeological survey has confirmed the early existence of another hall house in the row of cottages on Church Green in St Peter's Street. The crown post roof structure of Nos 70 and 72 suggests a construction date of around 1500. For some reason the house was truncated on its southern side, though built up again on both sides some 100 years after this date, forming the present Nos 66 and 68, and Nos 74 and 76 each as two additional single dwellings. By the early nineteenth century the whole was redeveloped, each house divided, and extended by a brick range across the rear to form six tenanted cottages, two up and two down. They have all in recent times come into individual ownership.

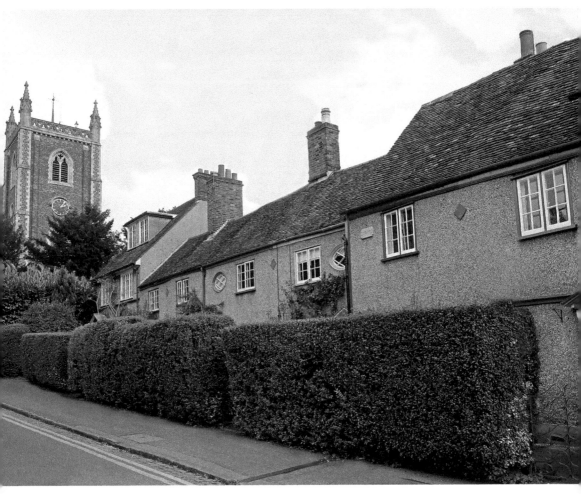

St Peter's Church Green. (Kari Lundgaard)

St Albans: Charter Borough

The Dissolution of the Monasteries in 1539 brought huge social change in the town. Abbey properties were given or sold, mostly to Court servants, and the actual monastery buildings pulled down and the materials used for construction elsewhere. One substantial beneficiary was Sir Richard Leigh (or Lee), military engineer, who built himself a splendid mansion on the site of the former nunnery at Sopwell.

13. Sopwell Ruins

The romantic ruins on parkland close to the River Ver at Sopwell are often miss-described as the remains of Sopwell Priory. They actually form a small part of a second house built later on the site of the priory. That house was abandoned in the eighteenth century by the then owner, Lord Grimston, and most of the materials transferred to his Gorhambury estate. The gardens continued to be maintained and worked, perhaps as a nursery, first by William Kilby, gardener at Gorhambury, then let to Richard Goodson, and, in 1757, to John Tompson, an inn holder. It is now a valuable green lung between the city and the St Julian's housing estate beyond.

Sopwell Ruins. (Courtesy of St Albans Museums)

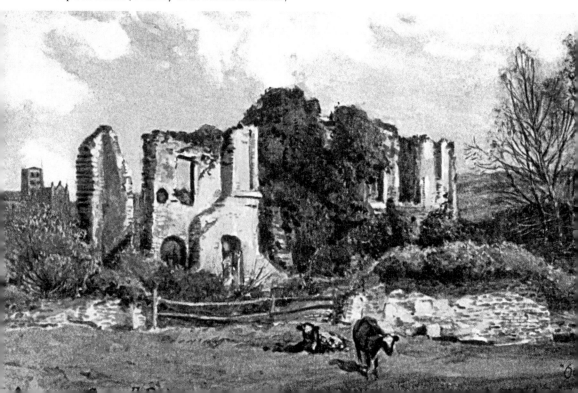

14. Gorhambury: the seat of the Earls of Verulam

The Grimstons are descendants of Sir Nicholas Bacon, Lord Keeper of the Great Seal to Queen Elizabeth I. Sir Nicholas built a mansion on his Gorhambury estate, where he expected to have to entertain the monarch on her processions. This occurred in 1572, when Good Queen Bess is said to have remarked, 'My Lord, what a little house you have gotten.' To which Bacon replied, 'Madam, my house is well, but you have made me too great for my house!'

Taking the Queen's complaint to heart, Bacon built a galleried extension before Her Majesty paid her next visit in 1577, but by the time William Luckyn inherited the estate from his great-uncle Sir Samuel Grimston in 1700, the house was in a state of disrepair. He was obliged to rent out a part of the mansion to meet the repair bills, but he took on the name of Grimston, and old Gorhambury was maintained until James Grimston, by then 3rd Viscount Grimston, decided in 1777 to replace it with a more fashionable mansion close by, and leave the old Tudor house to fall into ruin. It is now preserved as a scheduled ancient monument. Grimston's architect, Robert Taylor, completed the new mansion in 1784, shortly after he had been knighted for his work. It is still the Grimston family home, but the Palladian mansion is opened to the public on Thursday afternoons in the summer months.

The need for effective local government in the time of Edward VI, the young successor of Henry VIII, brought a charter for the borough of St Albans, creating the mayoralty and Corporation. The mayor and aldermen needed a court and a hall for the feasts, which marked all formal occasions, and a prison was needed to house miscreants.

Gorhambury House. (Darnell Collection © SAHAAS)

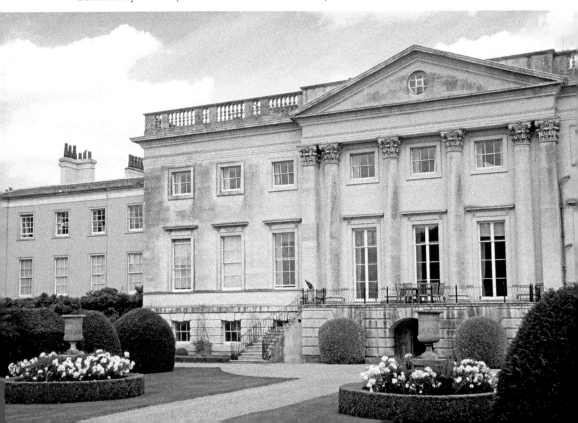

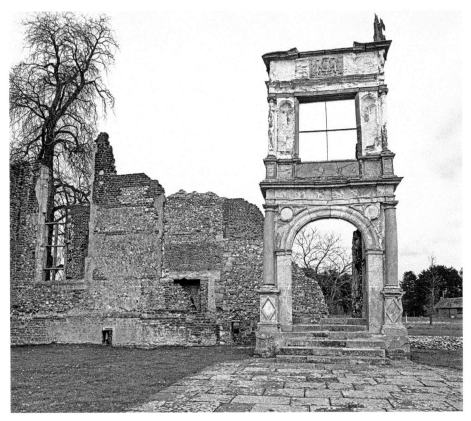

Ruins of Old Gorhambury. (Courtesy of St Albans Museums)

15. Former Borough Town Hall and Compter: the WHSmith Building in the Market Place

Within two or three decades of the charter's grant, a site was found on the north corner of Dagnall Lane, on the boundary between the Market Place in the Abbey parish and St Peter's parish, for a new 'Town Hall and Compter'. Compter is an old word for gaol, and that was provided on the ground floor, with a large meeting room above for functions. The fire engine later bought by the Corporation was also kept in this building. It remained the seat of local government until the nineteenth century, when a new courthouse was erected and the old building soon put to commercial use, early on as the offices of the newly established *Herts Advertiser* newspaper, published by Gibbs and Bamforth, printers, and now as WHSmith.

The seventeenth century saw something of a building boom in the town. It is not clear what prompted it, although the Civil War will have caused some destruction. Gradual improvements to the road surfaces, the introduction of coaches and the ever-increasing traffic along the significant routes through the town to and from London was good for business at the hostelries and for the town's economy in general. Two buildings in the market area reveal dates that show them to have existed at least as far back as this period, although they could be of even older origin.

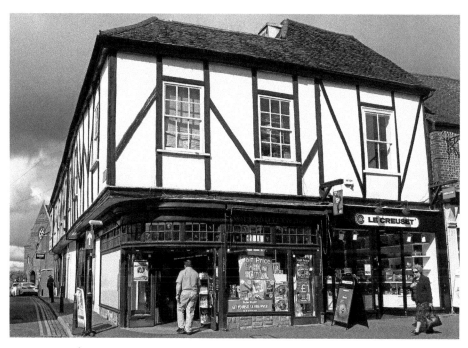

Above: WHSmith building, formerly the borough's Town Hall and Compter. (Bill Forster)

Below: The former Town Hall and Compter – now Gibbs and Bamforth printers. (Image rephotographed from the *Herts Advertiser* by Mike Neighbour)

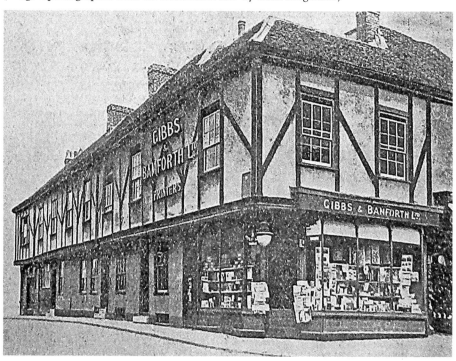

16. No. 17 High Street and No. 13 Market Place

No. 17 High Street is distinctive for the plaster rustication of its façade, with the inscribed date of 1665. Undoubtedly of much earlier date, it is, however, an example of the kind of decorative work usual in seventeenth-century St Albans, rather different from the pargetting more common further east in the county and East Anglia. The building that now houses Jack Wills at No. 13 Market Place also bears a date of at least a refurbishment if not a rebuild. It probably was built at the time of its advertised date of 1637 and may reflect a systematic upgrading and acknowledgement of the permanency of the temporary infill buildings in the market area. This encroachment on the highway for the market had been taking place from medieval times.

These Tudor and Stuart town centre buildings were timber framed and plastered, as was usual at the time. Only high-status houses were constructed of brick, although we do have an example of a more modest brick building in the almshouses at the north end of St Peter's Street, built following the death in 1627 of Roger Pemberton. Fire insurance companies established by the early eighteenth century recognised the greater risks of traditional construction and the cost of their premiums was no doubt pivotal to the gradual change we then see to brick and tile.

Below left: No. 17 High Street. (Courtesy of St Albans Museums)

Below right: No. 13 Market Place. (Kari Lundgaard)

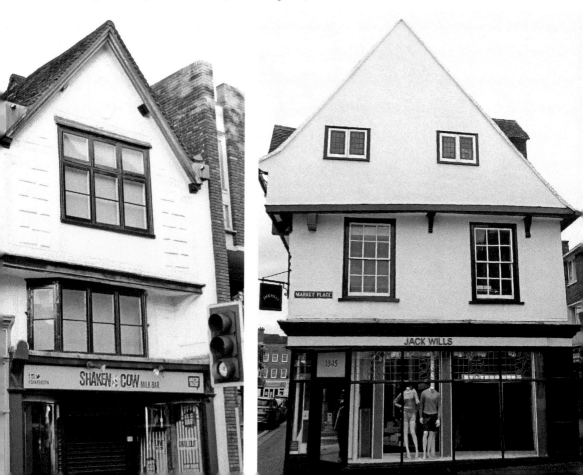

17. Pemberton Almshouses

With small, single rooms, and intended for six poor widows, the Pemberton Almshouses of 1627 were nevertheless substantially built. The boundary wall onto the highway was in accordance with Roger Pemberton's will. Their construction rather more reflects the status of the penitent benefactor than that of the residents over the years. Extended and repaired in 1905 by a member of the Pemberton family, they were bought by the District Council in 1944 for inclusion in its retirement housing portfolio. Further extensions in the 1960s provided a kitchen and bathroom for each unit; the age limit was reduced to fifty-five and men were now eligible for the accommodation in order to comply with the Sex Discrimination Act. The boundary wall is broken by an imposing gateway, which is topped by an arrow, said to symbolise a fatal hunting incident that led to the bequest.

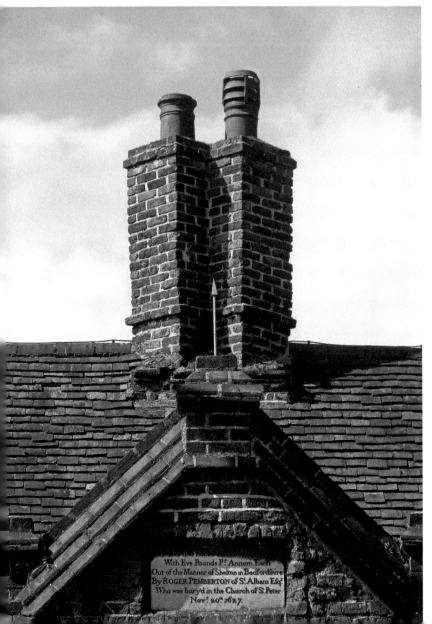

With Eve Pounds Pr Annum Each
Out of the Mannor of Shelton in Bedfordshire
By ROGER PEMBERTON of St Albans Esqr
Who was buryd in the Church of St Peter
Novr 20th 1627.

Entrance to Pemberton Almshouses with arrow. (Kari Lundgaard)

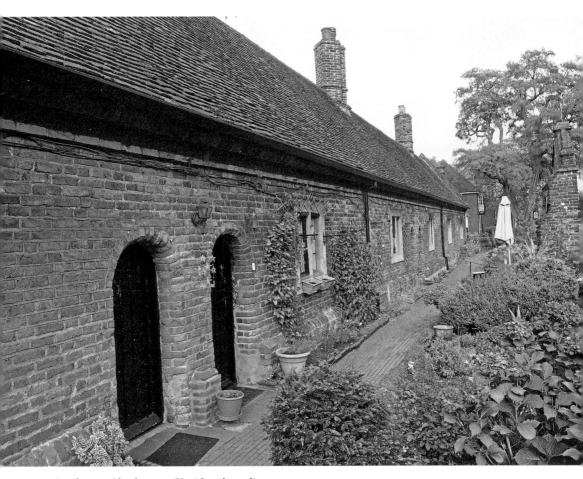

Pemberton Almshouses. (Kari Lundgaard)

18. Old Presbyterian Chapel, Dagnall Lane

Similarly substantial is the chapel built in 1698 for the St Albans Presbyterian community. On a site in Dagnall Lane – which ran from the Market Place along the rear of the inns on Church Street, or Cook's Row as George Street was then known – it provided a meeting place for the respectable Dissenting community of mostly trades and professional families. They had favoured independent worship over the reintroduction of the episcopal rule and liturgical ritual of the Anglican Church following the restoration of the monarchy in 1660. It was a plain building, with a door either side so that men and women could approach their separate seating areas independently. There were galleries to accommodate the large numbers of worshippers, said to be around 400, and a prominent pulpit opposite the entrances for the principal business of meetings; that is, to hear the word of the Lord from a preacher. The building was central to the life of the Dissenting community in the town for 130 or so years. Many prominent Dissenting ministers served regularly, or visited to preach charity sermons, including Philip Doddridge, Isaac Watts and, later, James Martineau. Now converted to another use, it still survives, though is much altered.

Above: Former Presbyterian Chapel, Dagnall Lane. (Kari Lundgaard)

Below: Presbyterian Chapel, Dagnall Lane, drawn by Holmes Winter, 1898. (Courtesy of St Albans Museums)

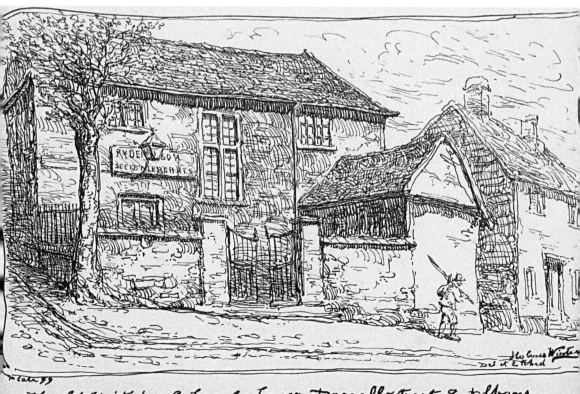

19. Spicer Street Independent Chapel

As the eighteenth century wore on, the slow rise of Unitarianism caused a schism, which overwhelmed the Presbyterian community, and Independent members left to form their own congregation elsewhere. By 1812 they were able to build their own separate Independent chapel in nearby Spicer Street. A gallery was added later, followed by a hall and Sunday school, to accommodate this very active community.

There were also smaller Quaker and Baptist meeting houses in the same vicinity from an early date.

Right: Spicer Street Independent Chapel. (Kari Lundgaard)

Below: Interior of Spicer Street Independent Chapel. (Chris Hawkes, courtesy of the church community)

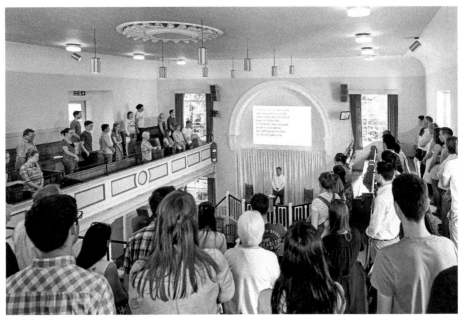

20. Dagnall Street Baptist Church

A chapel for the Baptist community was built in 1722 immediately behind the Town Hall on Dagnall Lane. It was demolished only after its replacement was built next to it in 1885, now with a baptistry and, unusually for nonconformist churches, stained-glass windows. The new church was one of several nonconformist churches to be built to accommodate the huge increase in population at the end of the nineteenth century.

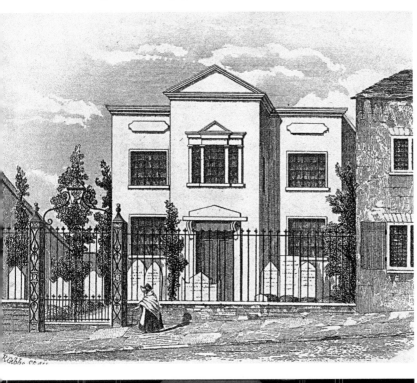

Dagnall Lane Baptist Chapel, built in 1722. (Courtesy of St Albans Museums)

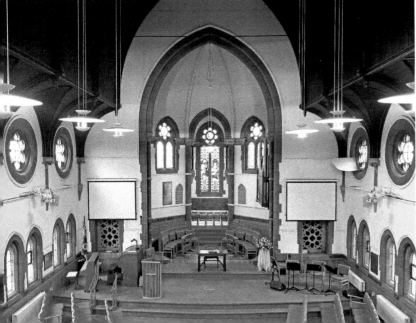

Baptistry at Dagnall Street Church. (Kari Lundgaard)

St Albans: An Eighteenth-Century Gentry Town

Turning into the eighteenth century, we see St Albans develop from a substantial market on a major route from the northern provinces to the metropolis, into a highly accessible commuter town, elegant, polite and fashionable and offering influential 'interest' to one of the wealthiest families in the land – the Spencers of Althorp. Politics became an industry, with the Spencer Whig interest based at Holywell House, now long demolished, and the Grimston Tory interest at Gorhambury and St Michael's. The borough's charter had granted the vote to all who paid scot and lot, or rates, so to more in St Albans than in many other similarly sized towns. In the tradition of the day, this meant great expense for candidates since treating was accepted practice. Though protagonists sought to secure Parliamentary seats by agreement rather than election, it was in the interests of the inhabitants for elections to take place. It not only made life much more interesting, but brought income to each and every ratepayer.

The Watling Street route from the increasingly fashionable West End via Kilburn and Edgware to the Northwest had been turnpiked in 1711, but, though an important route, this did not bring travellers directly into St Albans. In 1715, a turnpike was established from South Mimms to Bow Bridge just north of St Albans – in fact, conveniently, to Gorhambury. London became accessible for a day's outing as did St Albans for tourists. Property in St Albans became as attractive as it did following the twentieth-century electrification of the Thameslink line.

21. High Street, or The Vintry with Côte Brasserie, Waxhouse Gate and the former Red Lion Inn

The London Fire Insurance companies began to extend their coverage to the provinces in the early eighteenth century. The first policy for a St Albans property was that taken out with the Sun by James Agutter in 1717 for the Red Lyon Inn on High Street. Those with long memories may remember the commercial hotel of that name, which stood on the corner of Market Place in the 1960s and '70s. It now houses Zizzi's Italian restaurant. That Victorian brick building replaced an earlier inn of the same name built in the 1790s. It in turn had replaced Agutter's Red Lyon, which had spanned what is the present-day entrance to Verulam Road. It was an inn of some substance with, in 1756, stabling for sixty horses. In 1682, Thomas Baskerville had tarried awhile there when Mistress Selioke was the landlady. He tells us that she had a well there 40 fathoms deep.[3] Though water was pumped from the River Ver to the cisterns or the ponds on St Peter's Street at that time, most of the larger houses and inns would have had wells for their own water supply. Pumps in the Market Place and on St Peter's Green provided water for the general public as well, though they were constantly in need of repair.

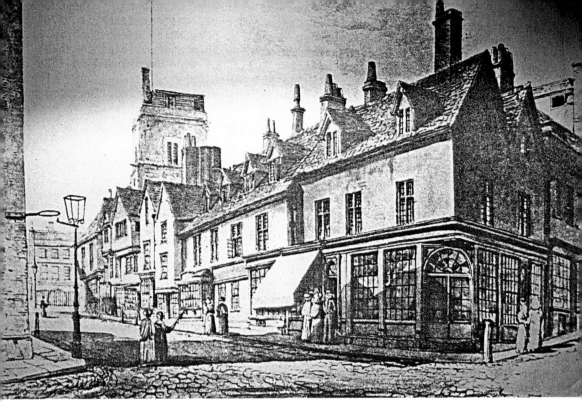

Above: The High Street in 1835, drawn by J. C. Buckler. (Image DE/Bg/3/140 © Hertfordshire Archives and Local Studies)

Below: The Great Red Lion, now Zizzi's Italian restaurant. (Photo Kari Lundgaard)

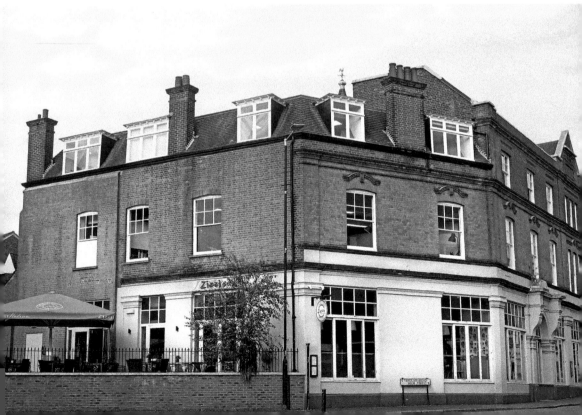

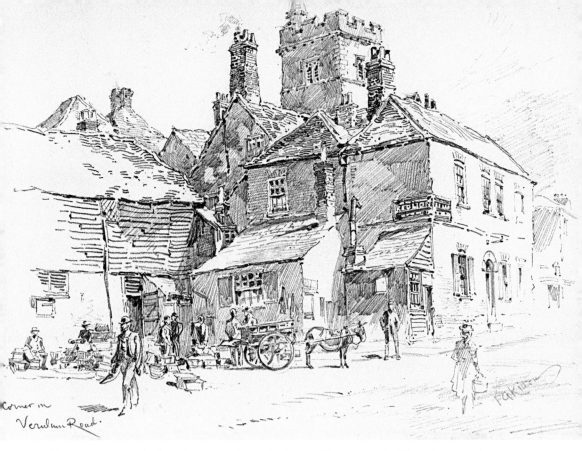

The Red Lion as rebuilt in the 1790s, drawn by Kitton. (Courtesy of St Albans Museums)

The Great Fire of London in 1666 prompted legislation demanding construction in brick, but in such places as St Albans, where building stone was in short supply and timber frames the norm, it was to be fashion and economics that brought about change. From the 1720s we see a plethora of town houses in brick in the more recent classical style and the re-fronting of many a timber-framed structure to give a similar appearance, many of which remain today.

The Vintry was how the section of High Street between the corner to Holywell Hill and the Waxhouse Gate was known. It fronted the Market Place, the hub of the town. One of the earliest houses in the new classical style was built for Thomas Cox on his estate in the heart of the town and is now Côte Brasserie, at No. 3 High Street. Cox had inherited his town centre property from his father-in-law Thomas Cowley, a wealthy merchant and sometime mayor of the borough. It was, like others the Cox family owned, previously monastic property. It included most of the High Street frontage and stretched back to the Vintry Garden behind, even including the Abbey Orchard beyond that. Rear access was from Holywell Hill, visible today next to No. 10.

The Vintry Garden is said to have earlier been a cemetery for the monks, but from at least the fourteenth century is described as the Vineyard or Vintry. By the early eighteenth century, the area was a high status neighbourhood, the premises of wealthy merchants and shopkeepers, reflecting the volume of trade that must have been undertaken here, not only by farmers with their corn and grain, and animals in the cattle market further north in the town, but drapers' and grocers' goods, with

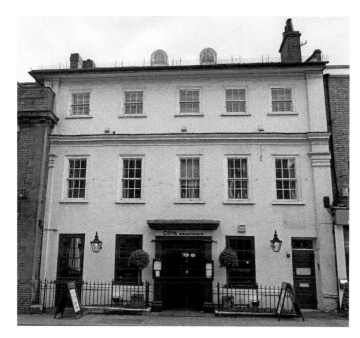

No. 3 High Street, built in the early eighteenth century for Thomas Cox, now Cote Restaurant. (Kari Lundgaard)

The secluded north-east corner of Vintry Gardens, where they connect to the rear of No. 3 High Street and No. 10 Holywell Hill. (Kari Lundgaard)

watches and clocks, books and tobacco pipes sold from shops, as well as the perishables brought to the market itself. A wagon service fetched and carried these goods to and from London. An advertisement following a change of hands in 1836 declares it had been established in 1721, when trade was perhaps at its height and there was great development in the town. The merchants would be replaced in later generations by medical men, lawyers and bankers, as the professions assumed a greater role in society, though several of the drapery businesses remained there even until the second half of the twentieth century. Three generations of Thomas Jones ran drapers' shops and in

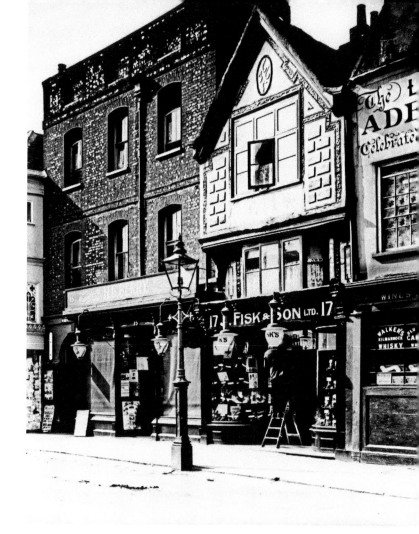

Right: William Fisk's store at No. 17 High Street. (Courtesy of St Albans Museums)

Below: Fisk's Department Store in 1925, where Heritage Close stands today. (Courtesy of the *Herts Advertiser* and Mike Neighbour)

 834 # The History of a Successful Business. **192**
A Firm Foundation——Sound Value the Secret.

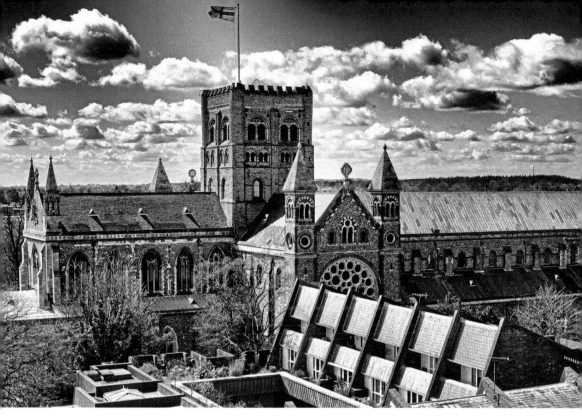

The cathedral and abbey church from the roof gardens in Heritage Close. (Norbert Rau)

1834 William Fisk established his shop further along the High Street; like most of these successful businessmen, he was a nonconformist. He belonged to the Baptist community and there is a memorial to him in the present church. Under his son, James, who was to be mayor of the city in 1878, his business grew to embrace several buildings where Heritage Close stands today, and become St Albans' first department store. Magnificent views of the nearby cathedral and of distant Gorhambury are to be found from the roof gardens of the flats above the shops there now.

Arthur Dorell came to St Albans in 1899 and also set up on the High Street. He had previously worked for Swan & Edgar on Regent Street and specialised in the repair of umbrellas. His store, initially at No. 29 High Street, after a time also spread across several buildings, east of Waxhouse Gate. Dorell's was taken over by the Selfridge Provincial Stores company in 1918, but when, in 1936, that company sold out, Dorell's was closed. The buildings were demolished and the present parade of shops and flats was built in their place. One of Dorell's buildings, now No. 9 High Street, was, in the early nineteenth century, occupied by surgeon Alderman Richard Webster. Webster was a political radical, prominent in the Contest Party, which sought to ensure that Parliamentary representatives were elected rather than appointed according to the influential families' interests. In 1841, the sitting members were the Tory, the Honourable Edward Harbottle Grimston, a keen cricketer, and the Liberal, banker George Alfred Muskett. Grimston wanted to take up a career in the Church and so sought the Stewardship of the Chiltern Hundreds, the accepted way of resigning a Parliamentary seat. The 'Blues' proposed to replace Grimston with Benjamin Bond Cabbell, but he was not seen by the Opposition as likely to be popular with the electorate, thus offering a chance on the radical side not only

to force an election but possibly to win it. Webster and the Liberal agent, Henry Edwards, who was also Muskett's Managing Clerk at his Bank of St Albans, at No. 2 Holywell Hill, went to London to seek a candidate. They came back with the Earl of Listowel, an Irish peer. Webster canvassed with Listowel and, as hoped, he won. The Tories presented a petition to Parliament, challenging the outcome, claiming that bribery had taken place. Such challenges were common, despite the uniformly accepted practice of treating. In this case the finger pointed at Webster, who, it was claimed, had bought the vote of one, Richard Adams, and paid a man, Stebbings, not to vote at all, since he said he intended voting for the Blues. Adams and Stebbings testified that they had been invited by Webster into the parlour behind his surgery, and asked how much they wanted for their votes. They asked for £20, but Webster put only two £5 banknotes, on the Bank of St Albans, and two gold sovereigns for each on the table. It was claimed that, having taken up the money, they had then gone to the Verulam Arms (now Verulam House Nursing Home), the headquarters of the Tory Party, and handed the money over. After recording the numbers of the notes, the money was sealed into a packet, taken back to Dr Webster's house and returned to his daughter. The questions the jury had to resolve were whether Webster's actions constituted bribery and whether Webster was in fact Listowel's agent, thus vulnerable to the accusation. The doctor was found 'Not Guilty'. It was said that the Tories had contrived the whole affair, and Webster was spared a spell in Newgate Prison. In 2016, a £5 banknote on that same Bank of St Albans fetched nearly £1,000 at auction. Still in fair condition, perhaps it was one of the controversial notes in question!

Dorell's Department Store shortly before its closure in 1936. (Courtesy of the *Herts Advertiser* and Mike Neighbour)

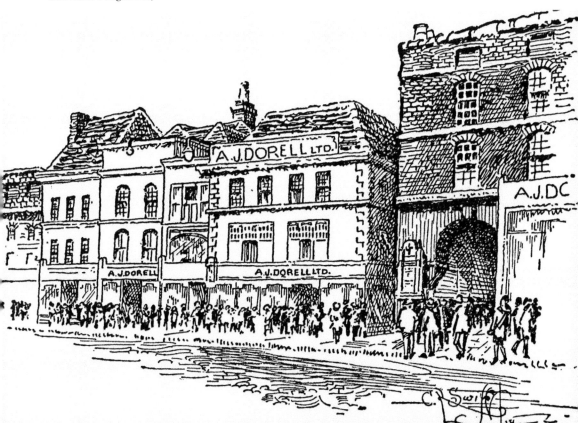

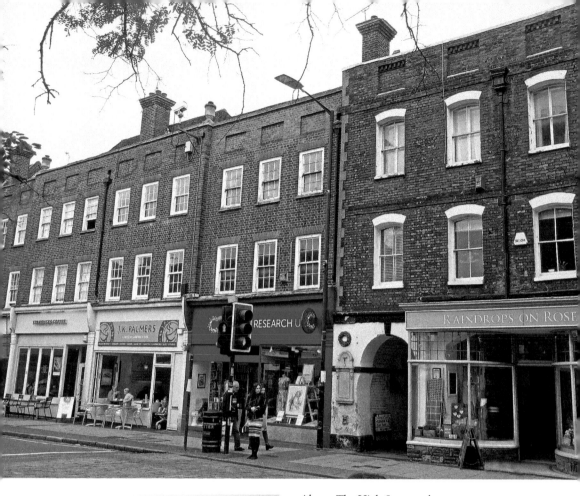

Above: The High Street today.
(Kari Lundgaard)

Left: No. 2 Holywell Hill, formerly the Bank
of St Albans. (Darnell Collection © SAHAAS)

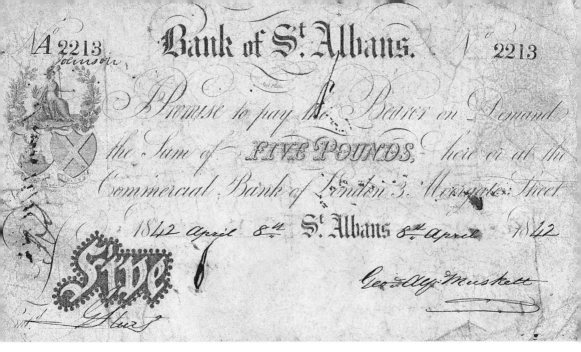

Banknote from the Bank of St Albans. (Courtesy of Spink & Son Ltd)

Joshua Pembroke, the son of a wealthy ironmonger and grocer, was the purchaser who broke up the Cox family property holding in the Vintry. He bought No. 3 High Street and the adjacent shops from them in the 1730s at a time when the family, following a number of deaths (some of them untimely), was no longer able to service its debts. The property was mortgaged to local surgeon Thomas Humphreys and to John Strong, son of the more famous Edward Strong, Christopher Wren's master mason at St Paul's Cathedral. The litigation over delays in the sale and claims by widows in the family over their 'thirds' (as widows' rights were known) gives details about the property, with its beautiful garden, newly planted with fruit trees and enclosed by a brand new brick walk, all neglected, it was claimed, due to the delays in conveyancing. There were arguments over the value, which was eventually fixed at £690, though in his will of 1740 Pembroke says that he paid £1,400 for it! Pembroke left the house to his elder son, George, a successful lawyer. His younger son, Joseph, also a lawyer, was later Town Clerk. George left the house to his son William, who sold it, in 1786, to another attorney, John Cowper. Cowper's will, proved in 1805, required that the freehold property should be sold to pay for the maintenance of his children. Cowper was described as lame, and it seems that his family did not reside with him at The Vintry. The sale advertisement describes the premises as suited to business as well as domestic use:

[An] excellent and very commodious dwelling-house with convenient domestic offices, counting-houses, courtyard, coachhouse, stabling, outbuildings and extensive pleasure ground and garden, part inclosed with walling and cloathed and planted with an abundance of fruit trees, the whole about an acre and a half. Further details on the premises from John Samuel Story.

John Samuel Story was Cowper's nephew and had joined him in the legal profession only shortly before, so it is perhaps no surprise that we soon find Story in ownership and occupation. On his death in 1851, occupation fell to Thomas Ward Blagg, another lawyer.

The early nineteenth century saw banks proliferating and these High Street properties at the heart of the town's business activity were where they were located in St Albans. At George

Muskett's Bank of St Albans, at No. 2 Holywell Hill, Managing Clerk, Henry Edwards, a local farmer with business ambition, lived above the shop, whilst Muskett himself lived in style at 'The Bury' in Rickmansworth. Muskett ran into serious financial difficulties as a result of a venture in Cornish mines and by 1841 his predicament was widely known. He wrote his will. It is possible that Webster realised that his political career was in jeopardy, which indeed proved to be the case when, later in the year, a General Election was called on Whig Lord Melbourne's failure to get his budget through Parliament. Listowel was returned again, but Cabell took Muskett's seat. Muskett died in 1843, and some suggested it was suicide. His brother came to St Albans immediately on his death and closed the bank before there could be a run. Both the bank property and the neighbouring No. 1 High Street, which he also owned, were sold. Edwards' banking career was at an end, and his secondary occupation, that of political agent, failing. He seems still to have had an eye to ventures, though his wheeling and dealing too resulted, in 1844, in a declaration of bankruptcy. One kite he had flown was the purchase of the Holywell House estate – it had previously been owned by Muskett – but it was soon sold on for others to develop. His political activities, however, revived, by now colluding with the opposition to secure the two Borough Parliamentary seats without election! Thomas Ward Blagg was the Tory agent and also Town Clerk and both were the focus of attention at the Bribery Commission's hearing, which resulted in the withdrawal of the borough's franchise after the 1850 by-election. Edwards had articled one of his sons, Isaac Newton Edwards, to Blagg. Town Clerk in succession to Blagg, we will hear more of Isaac in relation to another building later.

John Samuel Story too went into banking. Opened in 1844 at No. 3 High Street, his St Albans Bank was taken over by the London and County Bank on his bankruptcy in 1848. The London and County had opened a weekly agency in the town out of its Luton branch, but now its manager, John D. McKenzie, was able to open a fully fledged branch, which by 1851 was already relocated in St Peter's Street. It became part of the NatWest group and the branch is still there today.

Story's personal life had been as unsuccessful as his banking career. Born in the West Indies, he had come to St Albans and joined his uncle in the legal profession. In 1807 he married Mary Brideoake. Her mother was Elizabeth Gape and her grandmother, Jane, was sister of Viscount Grimston. Story became Clerk of the Peace in the county and had found the means to buy both his deceased uncle's house and quite a lot of other property besides. His estate was surveyed in 1840 and included the house in High Street, two houses in Holywell Hill, Orchard House in Abbey Orchard, Abbey Cottage, Abbey Mill House, three other houses in Abbey Mill Lane, and 20 acres 15 perches of land. Seven children were born to the marriage, but in 1832 Story uncovered his wife's adultery with her nephew. Unable to cope with this ignominy, he sued her for divorce. He had to pay substantial alimony, which must have been a drain on his resources, apart from the trauma of the situation. His banking career may well have been a hoped for way of recouping his losses, but, in only four years, this failed and he was insolvent. Story died in 1851 and the family left No. 3 High Street, though litigation within the family apparently prevented its sale for some time. On Blagg's death in 1875, the property was offered for sale, being described as freehold, with pleasure gardens, kitchen garden, stabling and coach house – in all more than an acre of ground. Blagg's personal effects – silver plate, 500 books, china, glass and furniture, thirty-five dozens of sherry, claret and Bordeaux, quarter cask of superior pale sherry, pony park phaeton, harness, stable utensils, garden tools and garden seats – were sold separately immediately after his death.

In 1862, Marten Call and Company had taken on the business of the unsuccessful Unity Joint Stock bank St Albans branch, recognising that many of their important clients were based in Hertfordshire. Initially at No. 5 High Street, following Blagg's death and the death of George Robert Marten, the local principal of the bank, the company bought No. 3 and Marten's nephew, George Nisbet Marten, moved in to reside and run the bank, and it was possibly he who added a further storey to the building. He had, fortuitously, recently returned from an unsuccessful venture in Queensland, Australia. He had just sold the sugar plantation he had bought there, which, though at first successful, had succumbed to rust epidemic which devastated the crops. The family owned the Marshalswick estate and George Nisbet's father, Thomas Powney Marten, succeeded his brother, George Robert, in living there until his death in 1889, when George Nisbet took up occupation. His manager, Charles Harris, moved into the bank premises, remaining there when the bank was taken over by Barclays in 1902. Barclays made it their local head office, which Harris recorded for the 1911 census as just 'Bank', St Albans, though it was clearly No. 3 High Street. High Street in that pre-First World War period was a busy, high-class shopping and banking area. Apart from the manager's accommodation, Barclays needed more office space. In 1919, the bank bought No. 1 next door and had it rebuilt to a design by Percival Blow. The Peahen corner, where Holywell Hill turns into the High Street, has been described as the busiest junction in the land, attracting one of the earliest sets of traffic lights, in 1932. The new bank building with its curved corner offered the opportunity for widening the footpath. Earlier in its life No. 1 had been the Corner Tavern, but for decades in the nineteenth century it was yet another draper's shop, and, for a while, one of Thomas Oakley's grocery outlets.

The garden of No. 3 High Street was lovingly maintained by Barclays' managers. A Mr Mitchell took charge in 1917, when, he said, there still stood a peach house and vine

High Street shops in the mid-twentieth century, with the Great Red Lion Hotel taken from the Peahen Corner. (Courtesy of St Albans Museums)

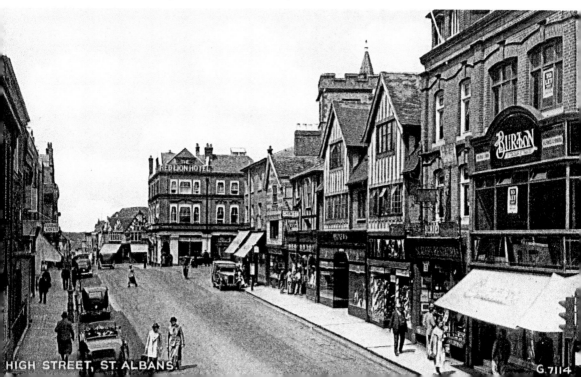

HIGH STREET, ST. ALBANS.

NEW BANK PREMISES FOR ST. ALBANS.

A HIGH-STREET DEVELOPMENT.

We publish above a drawing showing the new building to be erected at the corner of High-street and Holywell-hill, which will form an extension to Barclays Bank, Ltd.

The building has been designed by Mr. Percival C. Blow, A.R.I.B.A., of St. Albans, and will be carried out in dark red bricks with rubbed brick dressings, the corner being rounded off so as to broaden the path at this important crossing.

The work of construction has been entrusted to Messrs. C. Miskin & Sons, Ltd., and the demolition of the old building is in progress.

No. 1 High Street, Barclays Bank, from architect Percival Blow's drawing. (Courtesy of the *Herts Advertiser* and Mike Neighbour)

house, but since they were by then rather dilapidated, they were soon pulled down. The heating arrangement for the vine house was said to be on the same lines as the Roman hypocaust, with a furnace below the paving and ducts to discharge hot air at points in the paving. The mulberry, walnut and gingko trees were still in evidence, together with thirty other fruit trees – perhaps those planted by the Cox family – a pond and a lawn, which was at times used as a tennis court. A small part of the garden, largely then the kitchen garden, had already been sold to the church in 1876, when the Abbey's Lady Chapel had been reunited with the main part of the church. This had been the solution to the townspeople's outrage at the proposed closure of the passageway through the church, which linked the Waxhouse Gate path, previously known as School Lane, with the Abbey Orchard. It was the principal route used by workers at the Abbey Mills. An alternative route was provided, connecting the path with Sumpter Yard round the end of the Lady Chapel. In the second half of the twentieth century the Bank thought it more appropriate for the garden to be made available for enjoyment by the public. The Council was approached, but few funds were available for such garden maintenance and it took a while for this to be arranged. The garden, although beautiful, is now a shadow of its former self, though we have a record of its glory days, since the trees were, in 1971, the subject of tree preservation orders and the plan accompanying the order shows the location of each of those ancient and valuable trees. Sadly not all have survived, though the garden still provides a quiet place for contemplation and respite in the city centre. Barclays closed their offices in High Street in 1991 and No. 3 became a restaurant, now Côte Brasserie.

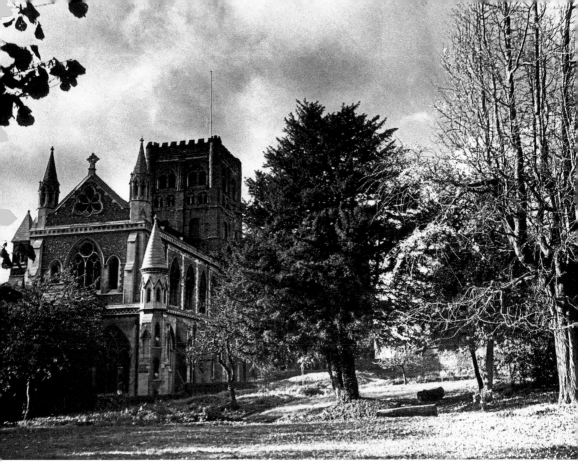

Above: Vintry Garden at the time it was taken over by the Local Authority in the early 1970s. (Courtesy of the *Herts Advertiser*)

Right: School Lane before the Cloister, or passageway through the Antechapel, was closed and the Lady Chapel reunited with the abbey church. (© SAHAAS)

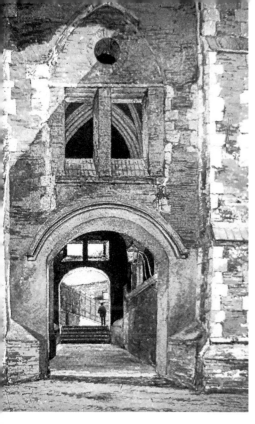

Left: Watercolour of the passageway from the south by J. Carter. (Courtesy of the archives at the Cathedral and Abbey Church of St Alban)

Below: The entrance to Vintry Garden through its eighteenth-century brick wall. (Kari Lundgaard)

Waxhouse Gate with house over it attributed to Edward Strong. (Kari Lundgaard)

The twentieth-century buildings on the south side of High Street now mostly accommodate smaller businesses, though the street remains the busy thoroughfare that it has been for over 300 years. The building which spans the Waxhouse Gate opposite the Clock Tower is datable to the early eighteenth-century period and is probably that described in Howard Colvin's *Biographical Dictionary of British Architects* as having been built by Edward Strong. Its drainpipe records a date in the 1720s. Stukeley has told us that the original gate was pulled down then. Edward Strong died in 1723 so it is questionable whether he was personally involved, but there is evidence of ownership of property in this location only a little later by his son, John Strong.

22. Dalton's Folly, also known as Bleak House

Born to a St Albans innkeeper, Thomas Dalton and his two brothers, William and John, had made their careers in London; in their case it was as stationers. Thomas was the youngest but the St Albans land and property fell to him and he sought to make the most of it. A field, or close, on the western side of the town had been neglected and a house beyond was not in good enough repair to rent out. He replaced that with a beautiful town house, just beyond the borough boundary, with an approach across the close from Dagnall Lane. This route is still recognisable in the footpath, which leads alongside the carpark on Verulam Road to Gombards and Folly Lane. Here, gentry tenants could entertain in style. The house rapidly became known as Dalton's Folly. Its architecture, and that of Ivy House, is well described in an article by architectural historian J. T. Smith, in which he suggests that both houses were built with entertainment in mind.[4] The pineapple finials on the entrance

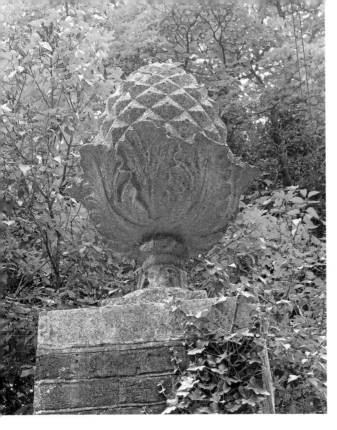

Pineapple finial at Darrowfield in
St Michael's Street. (Kari Lundgaard)

gates remind us of those gentlemanly days of the town (pineapples were a prized fruit at
the time Dalton House was built). Demonstrative hospitality was known even to include
the display of a hired pineapple at the table, and the gift of a pineapple to a lady from an
admirer showed particular eagerness. Their representation on gateposts was a symbol of
welcome to a gentleman's estate and more than one example can be found in the town.

Dalton House was bought in 1739 by the successful local surgeon Thomas Humphreys,
who had become an alderman and mayor. It was from here that he entertained his wealthier
patients (he practised from premises in the town centre) and Corporation colleagues and
enjoyed the country air and spectacular views. It then became the home of a Captain Phillips,
who rented the house at £66 per annum from Newgate Market salesman Thomas Fellowes,
then the home of a clergyman, and later still to a successful Holborn optician, Alderman
Samuel Jones. As mayor, Jones oversaw another period of great development in the town
with the building of the nineteenth-century courthouse and Town Hall. The close, or
field, which gave access to the house, was in this era lost to the estate, but Jones bought
the land behind and laid out a Victorian garden closer to his house. Garden Cottage off
Church Street, behind the house, could well be just that – for occupation by Jones' resident
gardener. Jones died in 1860 and the house remained in the hands of his legatees for some
time, but during the Second World War was taken over as a hostel for Land Army girls
before becoming offices for the Social Services department of the County Council.

After providing a setting for a firm of interior designers for a number of years it is now
being sympathetically updated and returned to family home. The iron railings provide
attractive protection without masking the classical façade of the house from public view.
Over the years, Samuel Jones' garden area has largely been overtaken by development.
Garden Fields emerged as a densely populated estate in the late nineteenth century.

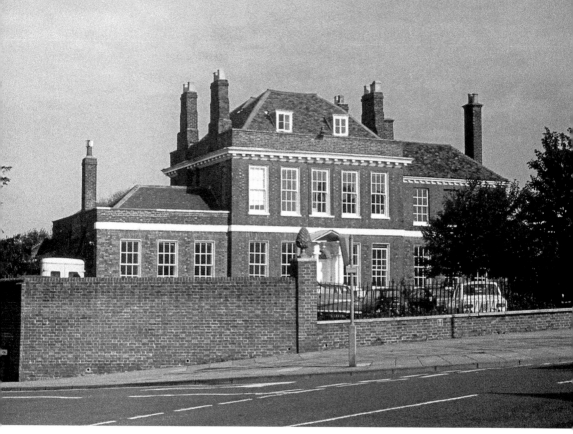

Dalton House, Folly Lane. (Willacy © SAHAAS)

23. Ivy House, No. 107 St Peter's Street

Dalton's Folly House was soon followed by another brick-built mansion in a similar style, now the offices of Debenhams Ottaway, a solicitors firm at No. 107 St Peter's Street. It was built for Revd Dr Robert Rumney as vicar of St Peter's. He had married the widowed daughter of the previous vicar, John Rochford, who had died in 1715 after fifty years' service. Having succeeded to the living, Rumney took up the challenge of modernising the church, the parish and his own accommodation. Rumney was already renting a house on the site from his wife's brother-in-law, John Cole, but the property was mortgaged. Rumney was now able to buy it out and build what he described in his will as 'my mansion'. Modest in the first instance, though of fine appearance, it was extended over time to both left and right, first by Rumney himself and later by James Brown, a gentlemanly antiquarian correspondent of John Nichols' *Gentleman's Magazine*. By then more land had been added to the estate and it was in farm use. Brown made the house his family home and laid out more pleasure gardens. On the death of his stepdaughter in 1858, it was let, then later sold, to lawyer Alderman George Debenham. It remained the Debenham family home until the 1930s, when it was sold and redeveloped. Family memorabilia show us how they enjoyed the estate, playing croquet on the lawn and tending the cow, beehives, etc. With ivy growing all over it, it became known as Ivy House. It is now occupied by the continuation of that family's firm, Debenhams Ottaway, as their offices, but the grounds have given way to detached houses and smaller gardens, with shops and flats on the road frontage.

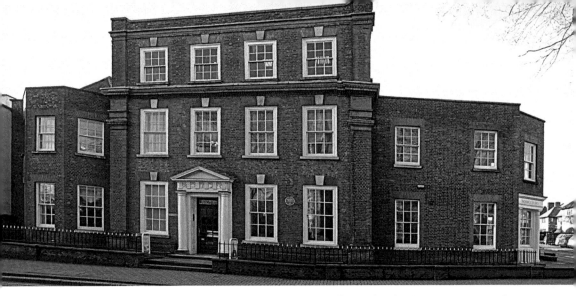

Above: Ivy House, No. 107 St Peter's Street, the offices of Debenhams Ottaway today. (Malcolm Merrick)

Below: The Debenham family in the garden of Ivy House. (Courtesy of the Debenham family)

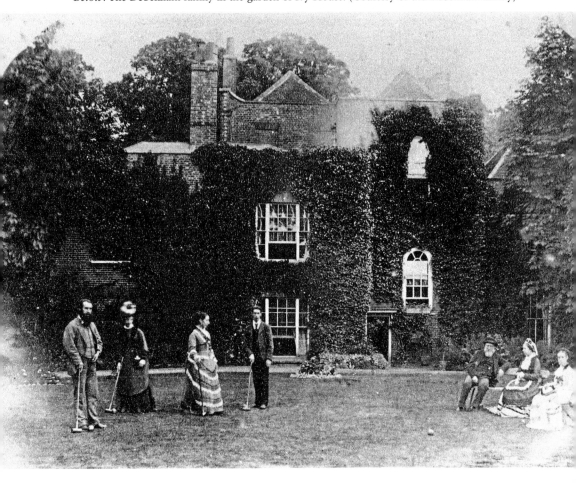

24. Romeland House

In the Abbey parish, beyond the High Street properties, we see another prestigious eighteenth-century house. Romeland House commands a view of the abbey church and Great Gateway across the now open space of Romeland, or Roomland as it was originally known. It also had, during its heyday, pleasure grounds and domestic offices to the rear. It was built for Dutch-born City merchant Frederick Vandermeulen, probably around 1760, and possibly by Robert Taylor. Houses are shown in this location on Benjamin Hare's map of 1634, though poor rate records for the early eighteenth-century show only several middle range properties there. In the 1760s it is referred to as 'new built', which seems to confirm its date. Like the other earlier mansions, it was not large as a family house, yet very grand in its appearance and interior. The entrance hall and reception rooms are larger than average and the detailing of ceilings and stairwell are particularly fine. Vandermeulen had married in London, in 1739, and his children were baptised at St Mary Abchurch in the City of London, but his youngest daughter, Elizabeth, was baptised at the abbey church in 1756, which seems to be the time he moved to St Albans, leaving his nephew, John, son of his Amsterdam-based older brother, to keep an eye on the business directly from the London premises. Apparently renting property in Spicer Street on his arrival, he accumulated land to the rear of his new house, extending the garden and constructing stable offices.

Romeland House. (Kari Lundgaard)

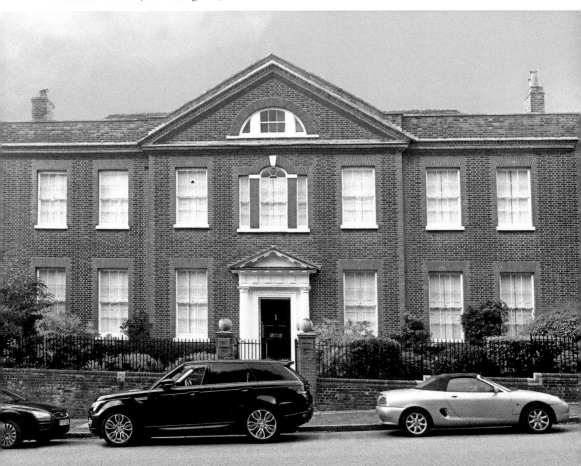

25. The Vine, Spicer Street

The house known as The Vine on Spicer Street was monastic property bought in the sixteenth century by Richard Rayneshaw. He left the large house and grounds to the mayor and Corporation, who, with the proceeds from it, should maintain the three cottages alongside in perpetuity for poor widows. The charity continues with almshouses rebuilt in the nineteenth century. The Corporation granted The Vine in the seventeenth century to Edward Carter, rector of abbey church, but he mortgaged it to his brother-in-law, Richard Hale. Hale, from St Albans, but Clerk of the Cheque in the Royal Navy at Portsmouth, tells us in his will of 1717 that he held the deeds to prove his title. He left the property to his niece, the rector's daughter, Mary, who was married to a Captain Molineux Robinson. A condition was to allow access to the gardens to a nephew, Charles Hale, to whom he left a recently refurbished apartment in the building. The fine gardens may well have been what was referred to in medieval documents as the monastery garden. We know they were sold in the middle of the eighteenth century by the owners of The Vine and though no deeds appear to survive, they seem to have become part of the pleasure grounds of Romeland House. The house became a public house in later years, but is now returned to domestic use. The decoration over its porch is illustrative of its chequered history.

Fishpool Street beyond Romeland was always a busy thoroughfare until it was bypassed by Thomas Telford's Verulam Road of 1826, when, despite the continuing presence of one or two fine houses, it gradually became a slum through which no respectable man allowed his daughter to pass. Recovered by refurbishment, by an enlightened Borough

The Vine, Spicer Street. (Courtesy of St Albans Museums)

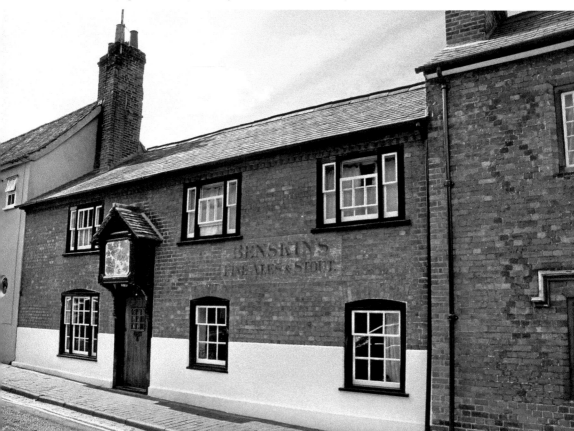

Surveyor, of some Council-owned property in the mid-twentieth century, it is now the bijou centre of the city's principal conservation area. With a number of inns and several alehouses lining its route, the street had enjoyed a certain respectability in the eighteenth century when the influential Gape family had rebuilt their home there, and another large house beyond, known as Manor Garden House today, was developed as an inn with fashionable Assembly Room.

26. St Michael's Manor, Fishpool Street

Now known as St Michael's Manor and an elite hotel and restaurant, the Gape family home had been the site of their tannery. Tanning requires access to water, which was provided by the River Ver on the southern side of the property. Though tanning is a rather unpleasant and odorous industry, the Gapes' business was highly successful and in the seventeenth century the family provided both mayors and representatives in Parliament for the borough. But soon the business had ceased, the sons entered the professions, and the family home was brought up to a fashionable and hospitable standard. The house retains many of the original eighteenth-century features and its garden, with lake and river beyond, make it a beautiful and popular venue for weddings and other functions.

St Michael's Manor, Fishpool Street. (Kari Lundgaard)

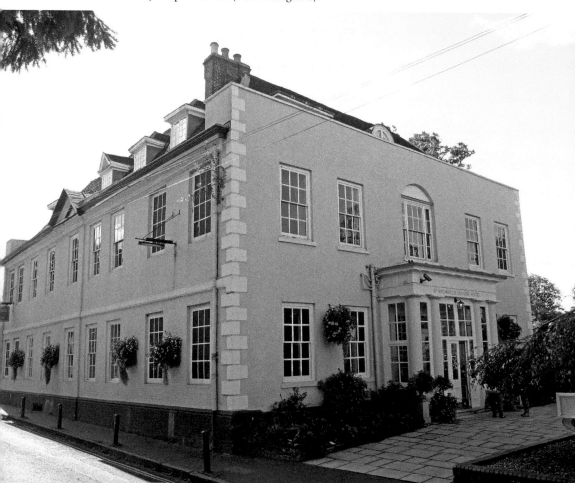

27. The Grange, No. 16 St Peter's Street

Another mayoral residence is to be found at No. 16 St Peter's Street. The Grange, as it is known, was built around 1760 by John Osborn, three times mayor of the borough. He had inherited wealth, including the mansion then on the site. The house today (the offices of Nationwide Building Society) stands prominent, though now only a handful of trees reflect its former glory and rural situation. A 'To Let' notice of 1809 tells us that the grounds comprised a pleasure ground enclosed on three sides with a brick wall, planted with fruit trees and shrubs of various kinds, a good kitchen-garden, melon ground, orchard, and about 2 acres of pasture land adjoining. This illustrates the gentry standing of the town in this era, though alehouses, workshops and pauper cottages could be found at the gates and dung heaps and other detritus still littered the street sides of the elite residences. With post chaises maintained by footmen and grooms to transport the gentlemen directly from their premises to their destinations, there would be little inconvenience caused by the stench of the markets, the animals wandering the streets, and the cisterns providing water for all the necessary purposes in the middle of this elegant street. The Grange estate remained a rural enclave in the middle of the town until as late as the early twentieth century, when the other house on the estate was demolished and a small cul-de-sac with Edwardian villas was cut through and named Grange Gardens. That street was in turn demolished in the 1960s, when the present Barclays Bank building appeared on the street frontage and the whole rear of the site to Bricket Road was developed for the Civic Centre, City Hall (now Alban Arena) and Magistrates' Court.

St Peter's Street at Michaelmas Fair in 1852, drawn by J. H. Buckingham. (Courtesy of St Albans Museums)

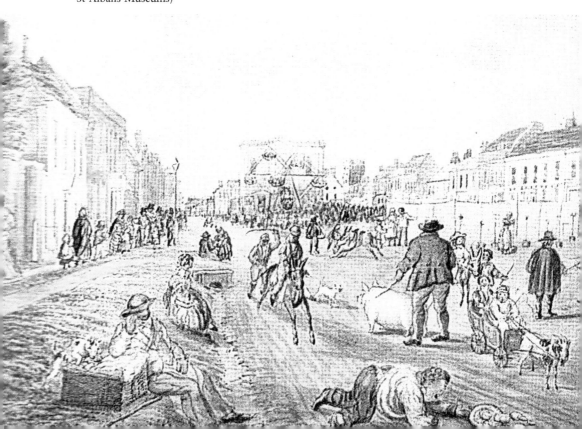

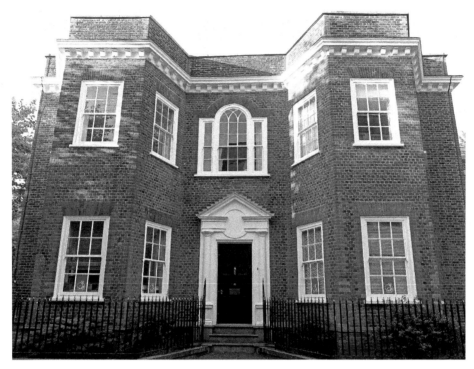

Above: The Grange, No. 16 St Peter's Street. (Kari Lundgaard)

Below: Grange Gardens. (Courtesy of the *Herts Advertiser*)

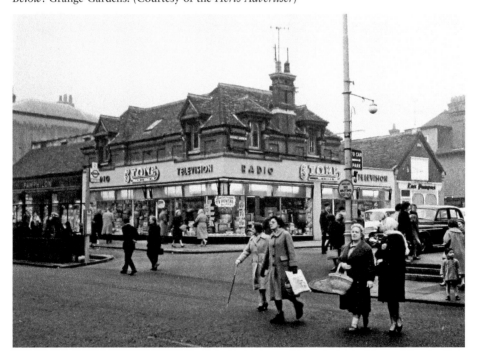

28. Water End Barn

In 1938, a seventeenth-century barn from the Brocket Estate at Water End near Wheathampstead was taken down and reconstructed on the Grange estate immediately behind the Broadway, a new parade of shops, next to the Post Office building on St Peter's Street. Where the Halifax Bank is now, two shops formed R. & J. Thrale's café, and the barn extended their premises to the rear, for restaurant use. Members of the Thrale family have recollections of the fountains, and photographs show them amongst the many trees still standing in the garden then. In the 1960s, another, even older, barn was brought to the site and erected alongside. Thrales café is long gone but the barns are still in hospitality use as part of the JD Wetherspoon pub chain.

Holywell Hill was always lined with inns on its east side and with alehouses, houses and shops on its shallower west side. At its foot, close to the river, was a substantial and ancient property, Holywell House, the St Albans home of the Jennings family, which was renovated and improved by Sarah and John Churchill in 1684, when they inherited it. It was Sarah's favourite residence and much time was spent here by the family. She left her St Albans and Sandridge estates to her grandson, John Spencer, and the house remained one of that family's properties until after the death of Georgiana, Countess Spencer in 1814. The road around the frontage of the house took the line of the present-day Grove Road, having been pushed out away from the house for the convenience of the family. Once the house was sold and demolished the road was straightened again, while the rest of the estate was gradually developed for housing. During the second half of the eighteenth century, as the principal residence of the Dowager Countess Spencer, it was the base from which the family's local political interests were nurtured. The name Holywell House is now attributed to the house of William Domville at No. 40 Holywell Hill.

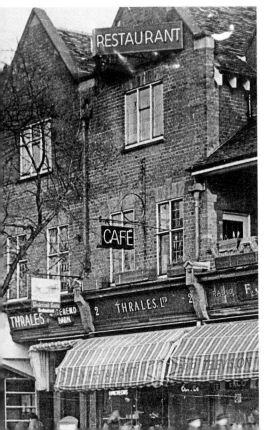

Thrale's Café in The Broadway, St Peter's Street. (Courtesy of the Thrale family)

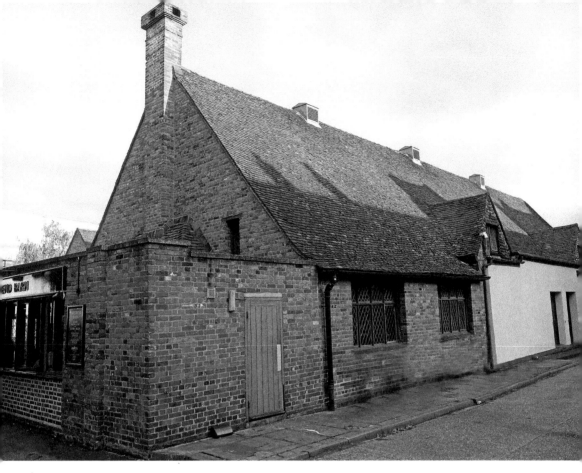

Above: Water End
Barn erected behind
St Peter's Street in 1938.
(Kari Lundgaard)

Right: Holywell
House, *c*. 1800, the
home of the Dowager
Countess Spencer, now
demolished: a drawing
copied by H. R. Wilton
Hall. (Courtesy of
St Albans Museums)

29. Holywell House, No. 40 Holywell Hill

Domville's Holywell House is one of the few early buildings in the town for which we do know the architect. Sir Robert Taylor, as he by then was, was engaged to build it for William (later Sir William) Domville in 1785. A native of the town, William Domville had made his career as a stationer in London, just as the Dalton brothers had before him. William and Charles Domville were booksellers and stationers of No. 95 Cornhill in 1784. William became Master of the Stationers' Company in 1803 and Lord Mayor of London in 1813–14. In 1821, he resigned as alderman for Queenhithe Ward, feeling the distance in to London too great to attend meetings sufficiently regularly, but he still continued to commute for business purposes. An 1828 letter from James Brown reads:

> My Neighbour Sir Wm Domville is truly a surprising Man – a much younger Man than I, though he entered into his 90th Year on or about last Twelfth Day & he goes to London on a Tuesday in the Stage coach, attends the Meeting of the Hand in Hand Fire Office, where he is a Director, & at your Copan's Hall, & then returns back in the Evening.

Domville was baptised in 1742, so may not have been quite ninety years old at this point, but he was clearly still a very energetic man in old age. A baronetcy was bestowed on him during his mayoral year, following the celebration at a banquet held at the Guildhall on 18 June 1814 of the supposed defeat and exiling to Elba of the Emperor Napoleon. As the guests arrived at the Guildhall, Sir William rode 'bareheaded and in a rich velvet robe on horseback before the carriage of the Prince Regent, carrying the Sword of State.'

Holywell House, No. 40 Holywell Hill, built by Sir Robert Taylor for William Domville. (Kari Lundgaard)

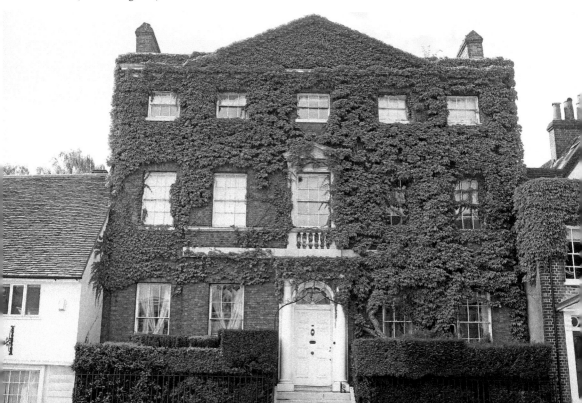

In retirement he purchased a house in Brighton in which to spend the winter months, but also became a magistrate in St Albans, chairing the Quarter Sessions, and remaining active until his death and burial in the abbey church in 1833. In the twentieth-century Holywell House was the home of unmarried sisters who ran a private school on the premises. Today the house is Grade II* listed and an important part of the town's built heritage.

Domestic architecture was not all that St Albans offered in the eighteenth century. Buildings from that era also include almshouses, chapels and mills, whilst schools operated out of existing buildings. The Duchess of Marlborough, having fallen out with her principal heir, grandson John Spencer, determined to spend a small fortune on the construction of an almshouse. Much thought went into the nature of the building, which was to be constructed on the site of the manor house of Newland Squillers, in Cock Lane,[5] which she had recently bought.

30. The Marlborough Buildings

The almshouse was to be seen as a philanthropic gesture, and the town was duly grateful, the Corporation, in 1733, unanimously voting the duchess's candidate into Parliament. However, the nature of the inmates was to change in the mind of the duchess more than once. In reality it became, initially, grace and favour homes for retired Army colleagues and other servants of her husband, the duke, and then those in need who applied to Countess Spencer who took personal care of the Marlborough Buildings later in the century. It is said that the forecourt was to have included a statue of Queen Anne by Rysbrack, commissioned by the Duchess in 1737, but it went instead to Blenheim Palace, where it now graces the

The Marlborough Buildings, Hatfield Road. (Kari Lundgaard)

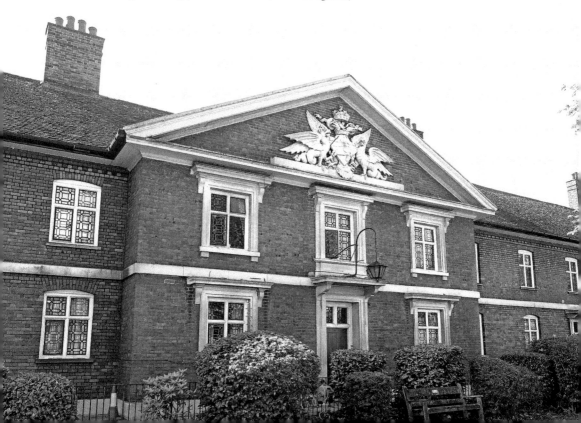

library. The Marlborough Buildings were altered somewhat in the nineteenth century, when the magnificent Marlborough Arms appeared to enhance the central entrance.

*

In 1720, the Society for the Promotion of Christian Knowledge had turned its attention from provision of charity schools to accommodation for the poor, offering premiums to those parishes establishing workhouses, where the unemployed could live and work. In 1723, the government passed legislation allowing parishes to refuse 'outdoor relief' to those seeking benefit, providing they offered accommodation in these workhouses. St Albans was quick to take advantage of this situation and such a house was quickly organised for the centre of the town. In 1724, St Peter's resolved to follow suit, and in 1732 the building which is now the offices of Rumball Sedgwick, estate agent, on Church Green appeared.

31. Rumball Sedgwick Estate Agents, formerly St Peter's Parish Workhouse

The red-brick building was constructed on the site of three cottages owned by the parish, and the opportunity was taken to improve and straighten the carriageway that led to the south door of the church at the same time.

Rumball Sedgwick, estate agents, formerly St Peter's Workhouse. John Horner Rumball, alderman and sometime mayor of the borough, was an agent for the Sun Fire Insurance Company. A fire mark on the front of the building confirms his own policy. (Kari Lundgaard)

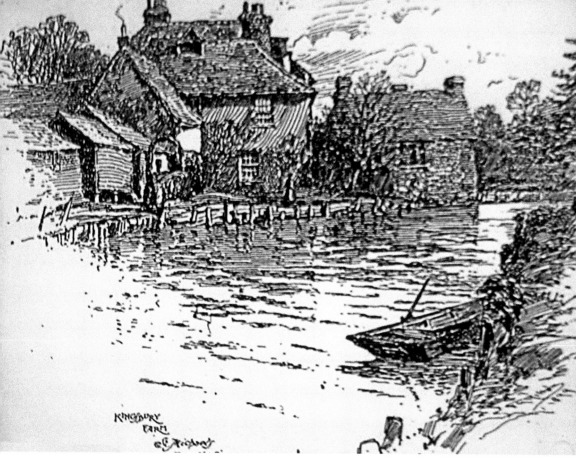

Nineteenth-century drawing of Kingsbury Mill by Kitton. (Courtesy of St Albans Museums)

The town was not without some diversified employment in this new industrial era. Taking advantage of water power from the river, some of the old mills were converted to new industries. Traditional corn-milling continued, as at Kingsbury Mill, but other mills manufactured paper, candlewick, and there was even some diamond polishing. In particular, the silk mills provided employment for many of the townspeople, though parish apprentices from London also swelled the workforce. Cotton mill employers were required to establish Sunday schools for the instruction and occupation of those apprentices. Such a school was indeed provided in the St Albans cotton mill at that time. Employment in the town remained broadly in the agricultural or domestic service sectors, until the railways supported new industries 100 years later, bringing the developments at Fleetville.

32. Abbey Mills

The Abbey Mills were taken over by the Woollams family in 1802 for silk throwing and rebuilt. The business thrived, employing as many as 500 people (mostly women and children) at its height. As steam became a resource, dependency on the rivers waned and production improved. In the case of the Woollams' business, it meant that they could open factories further afield, at Hatfield and more notably at Redbourn. The mill they built there is now a museum, having served as warehousing for Brooke Bond tea after the mill closed. The last of the Woollams entrepreneurs, Charles, became a substantial benefactor

in St Albans, in particular supporting the Grammar School where the family attended. The playing fields at Cheapside Farm on the Harpenden Road are named for him.

The early years of the eighteenth century brought formal education to the town for a wider section of the community. A day school was established by the Presbyterian minister, Samuel Clark, and there was a Bluecoat School associated with the established church at the Abbey. An industrial school, opened by the Countess Spencer to train girls for service, seems to have been located in a small building on the north–east corner of her Holywell estate – somewhere near the Hare and Hounds public house today. For boys seeking a more academic education and preparation for the universities, the law or other professions, there was the Free Grammar School. Grammar schools were not empowered to teach subjects other than the classics, though the masters frequently offered whatever was required for a substantial further fee. We know the boys in the Cox family attended the school – fees due to the master were a subject of the litigation already mentioned, as was the premium for John Cox's apprenticeship to surgeon Thomas Humphreys. His cousin, Thomas Cox, was articled to a London lawyer and his father had been apprenticed to a London goldsmith.

There was a fallow period for the grammar school later in the eighteenth century, with the master and rector of the abbey church, Revd Benjamin Preedy, admitting woefully that he had at the time no scholars at all, but that he stood willing to teach any who should come. The school was slated in the review of endowed schools undertaken in 1818 by antiquarian Nicholas Carlisle, but following the retirement of master Revd William Mogg Bowen in 1845 and a national review of grammar schools later in the century, it entered a period of reform. It moved from the Lady Chapel of the abbey church to the Abbey Gateway and soon expanded with new buildings on what had been adjacent open land. Local architects Samuel Flint Clarkson and Percival Blow both contributed to the beautiful buildings, which are the core of this now large independent school.

Abbey Mills, formerly Woollams' Silk Mill, now converted into apartments. (Kari Lundgaard)

There was also another option for families for whom the classics and the Establishment were either alien or irrelevant – nonconformists or those more interested in business and trade. In the 1780s, Samuel Heelas opened the St Albans Academy, where writing and bookkeeping were of greater importance.

33. Nos 101 and 101a St Peter's Street, formerly St Albans Academy

St Albans Academy operated until the 1840s from the house that is now occupied by Aviva, the cosmetic dental service, and Eurostyle barber shop. The master and boys lived in the house and lessons took place in a schoolroom behind, where St Peter's Mews now stands. A school for ladies was located next door before the White House was built. Newspaper advertisements tell us a little of how the boys' school was run and the layout of the site. A pew for fifty boys was reserved in the church across the road and another for the master and his family. Prominent parishioners all had pews of their own, which were kept locked, though there was an open pew at the rear reserved for the poor. A salaried pew opener attended for services. The last master of the school was Revd Andrew Donald, who, having become insolvent, moved to a living in Yorkshire. Shortly afterwards the building was taken over by Benjamin Amsden, from which he operated one of the many straw hat factories in the town.

Nos 101 and 101a St Peter's Street, formerly St Albans Academy. (Kari Lundgaard)

St Albans in the Nineteenth Century: Reform, City Status and the Arrival of the Railways

The Napoleonic Wars brought a halt to the period of Enlightenment, which had spawned the Industrial Revolution in Britain, and the ambitions of reformers were put on hold. St Albans played its part in those wars, though indirectly. Some men enlisted and others were drawn involuntarily to service overseas as the militia units were 'embodied' and sent to fight the war directly rather than simply training to defend the homeland should the dreaded invasion take place. Two local men would be honoured with the freedom of the borough following their service – Charles Vandermeulen and Captain James Gape, the latter particularly for his role at Waterloo.

The period of reform and industrialisation that followed the wars, though slow to take effect in St Albans, did bring specific changes. The parish workhouses were closed and sold off and a new Union Workhouse was built at Oster Hills to serve all the parishes. The Municipal Reform Act of 1835 changed the role of Aldermen, abolishing their life tenure and introducing the role of directly elected councillor. A move to consolidate the magistracy for borough, liberty and county in the town rather than in Hertford led to the construction of the new courthouse and Town Hall in St Peter's Street, replacing the Town Hall and Compter in the Market Place.

34. 'Old Town Hall'

The new courthouse building dominated the broad sweep of St Peter's Street and, though no longer adequate for Corporation nor courts today, it remains in ownership of the District Council, and is currently undergoing major refurbishment with a view to service as city museum and art gallery. George Smith was the architect engaged to design the new building. The location was chosen after several other suggestions had been rejected and was the site of a timber yard and Clark's almshouses. It is thought that the Abbot's Moot Hall had been somewhere on the same site in monastic times. Samuel Jones was largely responsible for relocating the almshouses and construction of the new building with court, Assembly Room, meeting rooms and prison cells, which was completed in 1831. In June 1832 James Brown wrote of the building:

> Our Magistrates have built us a new court House, well executed – acknowleged [sic] – but supposed to have cost the Liberty of St Albans, about £14,000 – and confessed? near half as big again as there was any occasion for; the true object of which seems to have been to out-vie Hertford, & to provide a Ball Room for the Ladies, 60 feet long.[6]

Spencer Street was cut about this time, providing direct access to the court from the turnpike bypass along Verulam Road.

Above: St Albans courthouse and Town Hall, St Peter's Street. (Darnell Collection ©SAHAAS)

Below: The new basement gallery will offer space for major international exhibitions in the town. (Annie Brewster)

Maybe to encourage the architect, or just to take advantage of his presence, Jones instructed Smith to build a gentleman's residence on the site of the young ladies' school, which he had just bought, along with the St Albans Academy building.

35. The White House, St Peter's Street

The house Smith built became known as the White House, though currently labelled LANSA house for the company whose offices occupied it most recently. The ladies' school moved to Donnington House on the east side of the street, now known as Mallinson House and occupied by the National Pharmacy Association. Among the occupants of the White House was William Page FSA, for a time secretary of SAHAAS and also editor of the *Victoria County History for Hertfordshire*. It stands prominent today and is awaiting its return to residential use after a period as offices.

Next to the White House was, until the twentieth century, St Peter's Vicarage. We do not know what this looked like before the present Tudor-style development, though it was certainly the vicarage.

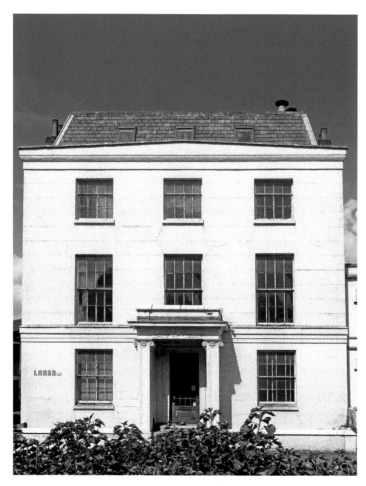

The White House, No. 103 St Peter's Street. (Kari Lundgaard)

36. No. 105 St Peter's Street, Formerly St Peter's Vicarage

The present building at No. 105 St Peter's Street was probably the initiative of St Peter's vicar Revd Charles Manners Norman, who arrived in 1824. Norman was an intellectual young man, the nephew of the 5th Duke of Rutland, and his patron was Edward Bowyer Sparke, Bishop of Ely, who had been tutor to his uncle. Whilst here, he shared his interest in debate with his neighbour, James Brown, and we are told by a Miss Howard, who knew them both, that they attended sermons at the new chapel at Spicer Street, but that this practice met with the disapproval of the bishop. In 1834, a more lucrative benefice in Northwold, in Norfolk, arose, and Sparke sent him there, where he stayed for the remainder of his life. Reverend William Crawley Leach, Sparke's own chaplain, came to St Peter's at that time of great change. Leach was keen to make his mark and sought to establish a National School in the parish.

The Chancellor of the Exchequer, Viscount Althorp, son of the 2nd Earl Spencer, was offering grants for the building of schools, where education and continuing maintenance could be funded locally – an early form of 'match funding'. The offer was in the main limited to Establishment National Schools. The British Schools, open to the children of families of all religious persuasions and run on the monitorial system devised by Joseph Lancaster, one of which had already been established in Spencer Street, had to find their

No. 105 St Peter's Street, formerly St Peter's Vicarage. (Kari Lundgaard)

own funding. Leach applied for support for a parish school to be built, he hoped, on land Lord Spencer would grant for the purpose in Cock Lane. The school was built and thrived, ultimately becoming a Board School under legislation later in the century, which obliged local authorities to provide school places for all children on a secular basis, rather than under Church auspices. All four St Albans parishes established National Schools, that for the Abbey parish being located in Spicer Street.

37. The Abbey National School Building, Spicer Street

The Abbey parish school survives as a Church of England, Voluntary Aided school, but was relocated in the 1970s to new premises at the foot of the Abbey Orchard. The St Albans School Board took over St Peter's School and incorporated the British School. Soon too small, the Board had a replacement built by Samuel Flint Clarkson. He was a noted church and school architect with a practice in Great Ormond Street, but lived in St Albans and was a leading member of SAHAAS. The Hatfield Road school was for boys, whilst girls and infants were provided for with similar schools at Garden Fields and on Alma Road, close to the new Midland Railway Station. The boys' school has been demolished in stages, firstly to provide a new Art School in the 1970s, and more recently

Abbey National Boys' School, Spicer Street. (Kari Lundgaard)

Architect Samuel Flint Clarkson's drawing for Alma Road Board School. (Courtesy of St Albans Museums)

to extend the playground of the Alban City School on the site. Garden Fields School, built for girls and infants of the Dalton Street, Church Street and Bernard Street area, is still in use but now as a community centre.

38. The Jubilee Centre

Clarkson's Garden Fields Board School was built in 1896 and continued to provide for city centre children until the 1970s, when a new school was built in Townsend Drive. The old building was retained and took on a further community role, which has been run for the last ten years by the Hertfordshire Independent Living Service. It provides meals for the elderly, rooms to hire and services to groups supporting those suffering from dementia and other difficulties.

There was considerable upset in the town as Board Schools were so heavily concentrated in St Peter's parish, but that was where the land could be found and where the greatest increase in population was taking place.

*

With cathedral status, the securing of the fabric of the ancient abbey church finally became a priority, though funding was still a problem. Here Lord Grimthorpe came to the rescue. Grimthorpe was a lawyer who had made his fortune through the railway legislation that dominated the nineteenth century, though his interests lay more particularly in horology and architecture. He and his wife had no children and he used his considerable wealth in satisfying these interests. He built himself a mansion at Batchwood, on rural land close to the town, carved out of the Gorhambury estate.

Jubilee Centre in Catherine Street, formerly Garden Fields Board School. (Kari Lundgaard)

39. Batchwood Hall

A turret on Lord Grimthorpe's splendid mansion at Batchwood displays a clock, the movement of which he designed himself, giving satisfaction to his horological interest. The design is the same as that which drives Big Ben's clock, which Grimthorpe also had a hand in. The house is now owned by the District Council and a nightclub operates in it. A comprehensive leisure centre and golf and bowls club is run in the grounds.

Lord Grimthorpe was prepared to spend vast sums on his architectural hobby, and launched into restoration of the town's ancient but ailing churches. First came the abbey church, or new Diocesan cathedral. Grimthorpe's love of the Gothic and hands-on approach was highly controversial. The West End of the abbey church was completely demolished under his auspices and replaced by a new one more suggestive of the architecture of French cathedrals than English ones. In the porch of the West End a memorial sculpture to the man who rescued yet bastardised this 1,000-year-old building can be seen, portraying him as a winged angel. The bust in the North Transept is possibly more flattering.

Apart from restoration work to the ancient ecclesiastical buildings in the town, the latter part of the nineteenth century also saw the creation of some new parishes, carved out of the existing ancient ones, and the construction of several new nonconformist buildings. St Paul's on Hatfield Road, recently magnificently refurbished, and St Mark's in Colney Heath became daughter churches of St Peter's, while St Peter's chapel of ease in London Colney became the church of a new parish. St Saviour's was to serve the Sandridge New Town, which was drawn into the borough.

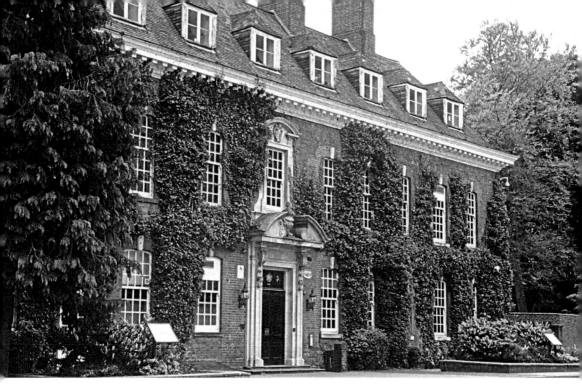

Above: Batchwood Hall. (Courtesy of St Albans Museums)

Below left: Turret clock at Batchwood Hall. (Darnell Collection ©SAHAAS)

Below right: Bust of Lord Grimthorpe in the North Transept of the cathedral. (Darnell Collection © SAHAAS)

40. St Saviour's Church, Sandpit Lane

The increased population to the north of the town, brought within the city boundary, was served by the new church at St Saviour's and the area designated as a new parish. The community had grown around the brickfields of Bernard's Heath. Built of local brick, St Saviour's beautiful interior reflects the High Church aspirations of its founders and clergy.

*

The Baptists built a fine new church adjacent to their old one, as already described. It was sympathetically extended on the site of the old building in 1989 to include meeting rooms and a drop-in lunch café, known as the Cross Street centre. Trinity Congregational Church was built with substantial support from local businessman Samuel Ryder in the area close to the Midland Railway Station (which was developing rapidly at that time), and also close by appeared the Roman Catholics' Church of St Alban and St Stephen. Methodists also built new churches, one on Marlborough Road, much supported by hat manufacturer Edward Scott, and one in the new industrial area of Fleetville. The Salvation Army erected a citadel in Victoria Street.

The demand for churches and schools resulted from the increase in population brought about by the arrival of the railways. This occurred later than in most towns, but now brought both employment and commuter opportunities. A branch line of the London and North Western Railway (LNWR) brought a connection to the national network at Watford in 1858, and this was followed by the line to Hatfield and the Great Northern Railway (GNR) in 1865. A general holiday was declared when the Watford branch line was opened. A direct link to London finally came when the Midland Railway line with its new terminus at St Pancras was built just three years later.

St Saviour's Church, Sandpit Lane. (Kari Lundgaard)

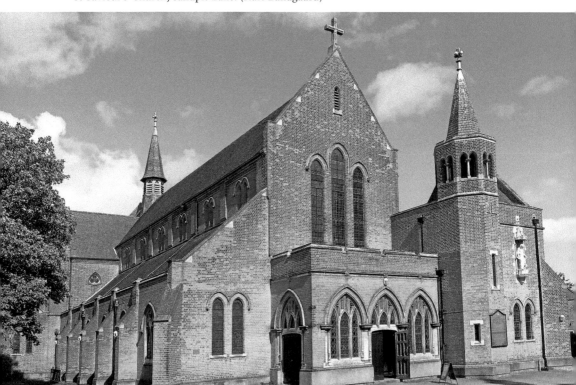

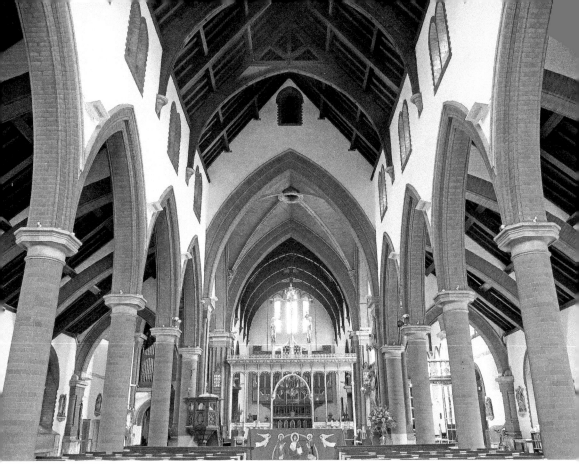

Above: Interior of St Saviour's Church.
(Kari Lundgaard)

Right: Dagnall Lane Baptist Church with
Cross Street Centre. (Kari Lundgaard)

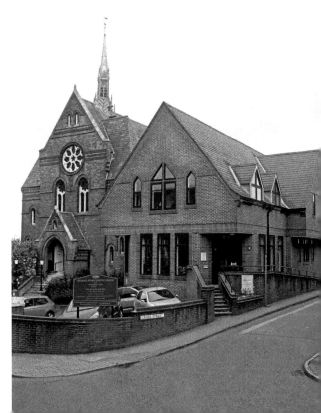

41. Signal Box (South) and Stationmaster's House

The new Midland station was at the end of Victoria Street, then known as Sweet Briar Lane,[7] to the east of the town centre. The pretty stationmaster's house on the west side of the line is the only evidence of the original station layout, which offered much better access from the town centre than the present arrangement. All else that remains of the railway's early days is the Signal Box (South), which is preserved and opened regularly by volunteers at weekends to demonstrate how the railway was run before today's automation. The station is now a busy commuter station and the line (Thameslink) is still the only one that takes passengers through London, rather than only to its original terminus.

<div align="center">*</div>

This area to the east of the town, mostly owned by the Spencer family, was a target for development of all kinds. Just beyond the station a site was found for the new prison building, which was to bring the town into line with national thought following the Prison Act of 1865.

Stationmaster's house, St Albans City station. (Kari Lundgaard)

Above: A steam train passing the signal box at the Midland Station. (Courtesy of the *Herts Advertiser*)

Below: St Albans Midland railway station. (© SAHAAS)

42. The Old Prison

Opened in 1867, the prison building replaced both the Liberty Gaol and House of Correction previously located in the Abbey Gateway and the long-term use of the cells below the Town Hall. The prison closed in 1924, though some buildings remain today. The governor's residence now houses the town's Register Office, and is a popular venue for couples signing up for their 'life sentence'. It is also a popular filming site, and many will remember seeing the Gateway in Ronnie Barker's wonderful series *Porridge* on television. Offices have been sympathetically built within the curtilage and a courtyard, Victoria Square, is now home to Mrs Isabella Worley's fountain from the Market Place.

*

The town's new accessibility via the railways brought industries, many establishing along the railway line to Hatfield. Sanders' orchids, Ballito's stockings, Smith's Printing Works and the Salvation Army all provided employment for the town's growing population, and indeed encouraged further growth; in particular the development of Fleetville. For employment, apart from domestic service, the town had previously been dependent on agriculture and its spin-off industry of straw plaiting and the hat trade. Sadly, almost all of this industry has now vanished and just a few buildings remain to remind us of those days.

St Albans Register Office, formerly the governor's residence at the old prison. (Courtesy of St Albans Museums)

43. Straw Hat Factory

There was a concentration of hat factories on Victoria Street. No. 53 Victoria Street, now offices for the Abbeyfield Society, was that of Edward Scott. They were supplied with plait by homeworkers, mostly women and children, which brought substantial additional income to the families of labourers and tradesmen. Kershaw's was on another corner in Victoria Street, but closed down in 1905 and the building was demolished. Many firms suffered from a loss of workforce during the First World War, though one company, E. Day Ltd, successfully diversified during the war, making straw sun helmets for the men serving overseas. Although Day did not survive long after the war, a small group bought out their

The offices of the Abbeyfield Society at No. 53 Victoria Street, formerly Scott's Hat Factory. (Kari Lundgaard)

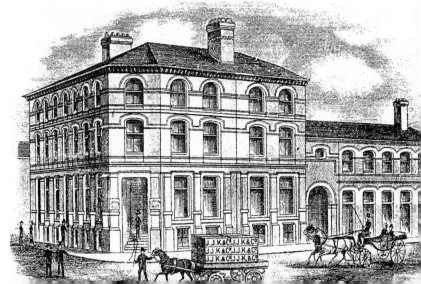

Business card for J. J. Kershaw & Co., whose factory was on the north-west corner at the junction of Victoria Street and Marlborough Road. (Courtesy of St Albans Museums)

Straw hats – an important part of nineteenth-century Hertfordshire's economy. (Courtesy of St Albans Museums)

helmet section and they thrived locally until a recent relocation to Scotland. The straw plait industry was successful throughout this area, and Luton has retained its connection with the trade in affectionately naming its football team 'The Hatters'.

44. Beaumont Works, Sutton Road

The factory building erected in 1899 for Nicholson's Coats still stands in Sutton Road in Fleetville, though as a shadow of its magnificence before Nicholson's was taken over by Chester Barrie in 1972.

*

Other facilities were required for this newly vibrant town, and clubs and theatres abounded. The Liberal Club, on land donated by Earl Spencer, remains today on Hatfield Road, now occupied by Veer Dhara restaurant below the offices of the Liberal Democrats, but the County Museum, next door, which opened in 1898 to house the collections of SAHAAS and its members, has fallen to residential development. St Peter's Institute next to the old museum, once the church's offices and halls, is now the home of the Yoga Centre and popular Courtyard Café. Also on the east side of town, outdoor leisure facilities were provided. Farmland bought from Lord Spencer and others by Sir John Blundell Maple for around £1,800 was laid out as Clarence Park. Both land and design were at Maple's expense, as a benefaction to the town.

The front door of Beaumont Works in Sutton Road, the factory of Nicholson & Co. (Coat Specialists). (Darnell Collection © SAHAAS)

Local Craftsmanship

THAT HAS
WON
UNIVERSAL
RENOWN

As a residential city St. Albans has become the home of many who appreciate the finer things. It is, therefore, appropriate that Nicholson Coats should be made there. Not only are they worn by leading residents, but their fine qualities have become universally recognised.

NICHOLSON
Overcoats

As fine as skill
can make them

NICHOLSON & CO. (Coat Specialists) LTD., BEAUMONT WORK
ST. ALBANS *Supplied to over 90 countries in the worl*

Advertisement for Nicholson's coats, 1965. (Darnell Collection © SAHAAS)

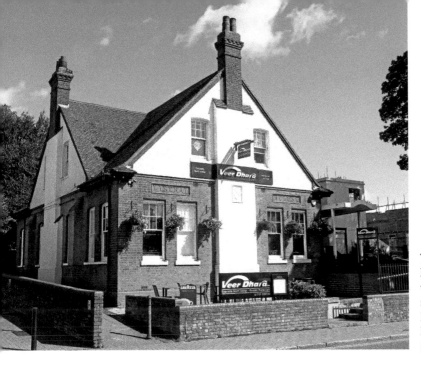

The Liberal Club in Hatfield Road, now with Veer Dhara restaurant below the Liberal Democrat Party offices. (Kari Lundgaard)

45. Clarence Park Cricket Pavilion

The 25-acre Clarence Park was opened on 23 July 1894 by the Duke of Cambridge, though the event was somewhat marred by torrential rain. Cricket was one of Blundell Maple's favourite sports and the iconic pavilion dominates the park. It is available for hire for private events and is still used as changing rooms and for refreshment at sporting events. The granite drinking fountain was the gift of Lady Maple. The wooden bandstand, roofed with thatch, burned down, but a Heritage Lottery grant in 1997 paid for its replacement.

Cricket Pavilion at Clarence Park, opened in 1894. (Drawing by Kitton photographed by Kari Lundgaard, courtesy of St Albans Cricket Club)

St Albans in the Twentieth and Twenty-First Centuries

Employment and commuting opportunities spawned much more residential development in the Edwardian era, notably St Peter's Park around Hall Place Gardens, where examples of Percival Blow's trademark work can be found. The name of one new local industry remains in people's minds today both at home and abroad, though with little recognition of its St Albans origins. Samuel Ryder sold his penny seed packets by mail order from the town to the ever-increasing number of house owners keen to maintain the gardens of their three-bed semis. The novel idea brought Ryder a fortune and he soon built himself imposing offices on Holywell Hill and a conservatory-style seed hall in which he could garner and store his seeds.

46. Ryder Seed Hall and Offices

Both seed hall and offices for Samuel Ryder were built by Percival Blow, who was responsible for many of the shops and houses in the town at that time. The offices are now a hotel and the seed hall the Café Rouge restaurant. In the 1920s, Ryder established a second business, Heath and Heather, with his younger brother James. Based in a former hat factory near the Midland station, and with a retail outlet in High Street, this soon developed into a chain of retail shops offering herbal teas and herbal cures for constipation, asthma,

Ryder's Seed Hall, now Café Rouge. (Kari Lundgaard)

Ryder's offices, now the Clarion Collection Hotel. (Kari Lundgaard)

anaemia and every other ailment – including a smoking mixture, which was made up of around 50 per cent coltsfoot leaves, plus clover, lavender and rose petals. This mixture was to become a valuable substitute as tobacco became hard to come by during the Second World War.

Samuel became an alderman and mayor of the borough. A nonconformist, a member of the congregation at the Spicer Street Independent Chapel, he was a driving force behind the construction of Trinity (now United Reformed) Church. In failing health, it was recommended that he take more exercise, and so he joined the Verulam Golf Club. His wealth allowed him largesse and he donated a cup for a competition between American and European golfers. The competition continues today amidst much international interest, though few know much of that amateur golfer who instigated it.

*

The twentieth century brought the invention of moving pictures and St Albans contributed to their development. The thriving present-day Odyssey cinema on London Road is part of St Albans history and that of the industry as a whole.

47. Odyssey Cinema

Reopened in 2014 after nearly twenty years of closure, the Odyssey is a great asset for the town, which was for so long dependent on occasional film festivals. It is a fitting tribute to independent cinematographer Arthur Melbourne-Cooper, who lived and

worked in the town. Built as the Capitol, it opened in December 1931. It replaced an earlier cinema destroyed by fire a few years earlier. The earlier building of 1908, known as the Alpha Picture Palace, had been the work of Percival Blow for Melbourne-Cooper to show his animated films and house his studios. As an Odeon, it was closed in 1995 by the Rank Organisation, who had just opened their new multiplex at Jarman Park in Hemel Hempstead. Local campaigners did not give up trying to bring film back to the town, either at the former Odeon site or elsewhere. In time, since it proved impossible to develop the old Odeon site for residential development on account of the large drop in the land at the back of the site and the lack of space on the main London Road frontage for the necessary construction work, a plan for reopening the old cinema was formed. The vintage building was eventually sold back for restoration by James Hannaway, who had already rescued a similar cinema in Berkhamsted, the Rex.

Little development took place during the war years of the 1940s, but thereafter the need for housing and schools brought the advent of new towns north of London, four of them in Hertfordshire. The face of the county changed beyond recognition with aircraft and pharmaceutical industries providing jobs for thousands. St Albans saw a great expansion of housing, resulting in large Council estates at Cottonmill, New Greens and London Colney, as well as private developments at Marshalswick and the Verulam estate. The County Council as the Education Authority responded to the need for renewal of many old Victorian schools, and the provision of new ones on estates where none had been

Odyssey Cinema, London Road. (Kari Lundgaard)

before. The need for an additional school in the town centre prompted the purchase of land behind St Peter's Street to the south of Adelaide Street. Thus began a major change in the appearance of this part of the town centre and ended the elegant and gentlemanly era of residential occupation in St Peter's Street. As a result we now have a school with the rather unlikely local name of Aboyne Lodge.

48. Aboyne Lodge School

Major 'development' in the town centre prompted the statutory listing of many old buildings and the establishment of the first Conservation Area in the town. Strangely, the Adelaide, as it was then called, survived likely demolition or compulsory purchase, though was never listed. There had until this time been little development immediately behind St Peter's Street, on either east or west sides. Adelaide Street had been cut and built up in the 1830s, and the Spencer Park estate had been built beyond. Now, the garden of Mr Gerald Wilton Williams's house, Aboyne Lodge, with more than 100 fruit trees and possibly even more rosebushes, was to be taken, partly to provide space for the cutting through of Drover's Way to the cattle market and to find land for the new school. Aboyne Lodge was the name given by James Betts, distiller of London, to his new house on St Peter's Street. It had been where Revd Mogg Bowen, alderman and master of the Grammar School, had

One of the first 'Hertfordshire' schools built in the garden of Aboyne Lodge. (Kari Lundgaard, original image held by the school)

lived. Constructed – or at the very least massively refurbished – by Betts sometime shortly before 1870, the garden had in the 1920s and '30s been the pride and joy of Mr Williams. He moved in 1938, taking many of the rosebushes with him, and the fate of both house and garden were sealed. However, the school that was to appear at the rear of the site has its value too, not only in educational terms, but architectural ones too. In solving the problem of such a challenge, the County Council employed architects with the sole remit of providing a large number of new schools as cheaply and quickly as possible. They came up with a scheme, which was emulated throughout the land. Aboyne Lodge was to be perhaps the first and certainly one of the best examples of a primary school under this scheme, which has earned it listed building status. The Aboyne Lodge house was demolished and a large but pleasant block with shopfronts erected in its place, the façade of which has been preserved in the construction of the new Premier Inn.

The County Council's architects were tasked with provision of buildings for tertiary education and a further education college was built on the site of Edwardian villas on the north side of Hatfield Road. The City College and the Building College on the same site served the population well, but as further education was taken out of local authority control the need for economies of scale and the elimination of funding for evening leisure classes spelled doom. Colleges were amalgamated and gathered together on more economical sites than the prime building land of central St Albans, capable of conversion to residential use.

49. Oaklands Village

Oaklands Village served to help meet the District Council's housing targets. Hundreds of flats were constructed on the site of the original college and several nearby houses that had been taken into educational use. The Administration block of the college was recognised

Administration block of St Albans City College, now apartments. (Kari Lundgaard)

as a fine example of that type of the Hertfordshire architects' educational scheme, was spot listed and thus saved for posterity. That determined the design of the additional flats that would be built around it and so a new modern style was introduced into the town's streetscape – perhaps the first major change in the town's appearance since the building boom of the eighteenth century.

*

The town had acquired a swimming pool close to the River Ver at the bottom of Cottonmill Lane in the late nineteenth century. It is still there, but used now only by subaqua clubs. The 1970s saw the opportunity to buy land next to what had been the Westminster Lodge estate, the land of Brown's farm and where huts accommodating an Army camp had been built, for a brand new swimming pool. It was given the name of Westminster Lodge. This served well but by the turn into the twenty-first century it had also exceeded its sell-by date. A replacement was needed and that became a major project of the District Council.

50. Westminster Lodge Leisure Centre

The new leisure centre was completed in 2012. The name Westminster Lodge is now familiar throughout this community, but it gives no clues about the history of the site, nor the Lodge itself. The flats built on the site behind the leisure centre are called

Westminster Lodge Leisure Centre. (Kari Lundgaard)

Westminster Court. The imposing gateway building near the roundabout, which houses a veterinary practice, begs further question. It is in fact the stable block of the Westminster Lodge Estate. The name has otherwise been lost, and was indeed short-lived. It was the grand new residence of Town Clerk Isaac Newton Edwards, the attorney son of Henry Edwards. Built in the 1870s on land leased from the Gape family, it was one of the largest mansions in the borough, continuing in fine style the town's tradition of gentry houses. It had thirteen bedrooms, four reception rooms and a billiard room. Westminster Lodge was the imposing name Edwards gave to it. Like his father, he was an active political agent, and not only on his home territory. He also inherited his father's penchant for wheeling and dealing. Lessons already learned by his father apparently passed him by, as he too was made bankrupt following questionable deals in the relation to land he owned at the junction of Victoria Street and Chequer Street. He was struck off the Roll of Solicitors, and by 1888 had to sell the estate and move away. After several decades as the home of another wealthy resident, Edwards' house and outbuildings became offices for Eversheds' printing works and then the headquarters of the Youth Hostel Association. The name was changed to reflect the founding of that Association by Dr George Trevelyan and, now converted into apartments with more flats built in the grounds, it remains Trevelyan Place today.

Endnotes

1. The Character Statement for the St Albans Conservation Area can be found at www. stalbans.gov.uk/planning/conservation.
2. Though the current (2nd) edition is now out of print, a new edition for Hertfordshire in the *Pevsner Architectural Guides: Buildings of England* series is due to be published by Yale University Press in spring 2019.
3. A fathom is 6 ft long, or 1.828 m., so the well would have been 240 ft or 73 m. deep.
4. 'Two Houses designed for entertainment?' in *Hertfordshire Archaeology and History*, Vol. 14, 2004–5, pp. 143–52.
5. Cock Lane was the name of present-day Hatfield Road in the town. The road was turnpiked in 1768 to provide a connection between the Great North Road and the road to Bath, avoiding the need to travel through London, a sort of early M25.
6. *The Old Town Hall, St Albans* was written by Chris Green and published by SAHAAS in 2017 (ISBN: 978-0-901194-10-7). It describes the building in detail.
7. Sweet Briar Lane was renamed Victoria Street when the Queen bestowed city status on the borough following the designation of the abbey church as a cathedral and the centre of the new Diocese of St Albans in 1877.